CW00557587

THE BLUE CUPBOARD

Jane I. Darrall
6th January 2015
Hampstead
2

THE BLUE CUPBOARD

Inspirations and Recollections

TESS JARAY

Royal Academy of Arts

This book is dedicated to my mother Pauli
and to all those who remember her.

CONTENTS

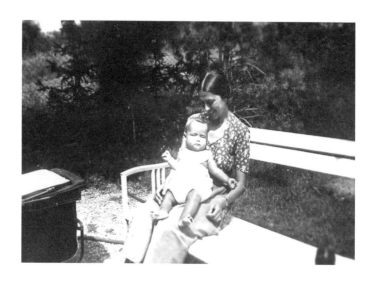

My mother Pauli with me, 1938

This book was started as a memoir of my mother and subsequently developed into something more like a diary, covering my recollections of a postwar childhood in Worcestershire, an art-school education and subsequent obsessions. It may be read in the light, or perhaps one should say in the shadow, of its political history. Pauli and her husband Franz were part of the influx of immigrants offered sanctuary in Britain in the late 1930s, in the face of the sweeping tide of fascism in Central Europe. They and I, their daughter, the author of this 'memoir', were the only members of their immediate family to escape; the others all perished in the camps. Unlike most immigrants – who, no matter when or from where they left, usually make new homes in cities – my parents settled alone in an isolated part of the English countryside. I think of the survival of Pauli and her family in terms of the redeeming powers of nature and the strength of her own remarkable life force.

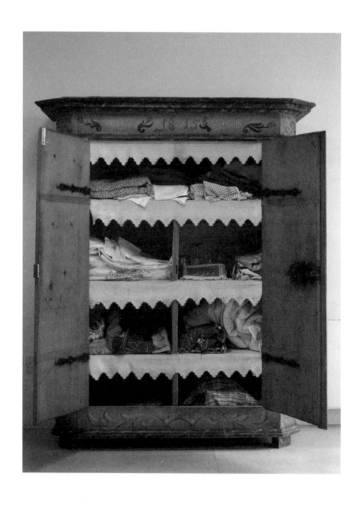

Inside the blue cupboard

1. THE BLUE CUPBOARD

There was a blue painted cupboard in the room in which my father slept; at least, he slept there when he was old, and indeed so did my mother after he died. They never shared a bedroom: when they married in Vienna in the early 1930s it was fashionable to have separate rooms. There were many ribald jokes, apparently, about the consequences of this trend. My parents had separate rooms throughout the 52 years of their stormy married life, although my mother complained bitterly about my father's marital demands, well into his old age, and after strokes and heart attacks.

The room is small, with a low oak-beamed ceiling, and floored with broad elm boards. There were three things of particular beauty in that room, but the most wonderful was the old blue painted cupboard. It is not just plain blue, but inset with four panels painted with bouquets of flowers – frontal, formal, childlike in their conception of what flowers should look like, and painted in reds, pinks, white and blue, all now faded to that patina that can never be achieved other than over time. The panels are surrounded with garlands, which also wreathe the edges of the cupboard, almost turning it into a painting. A date is written at the top in decorative Gothic lettering: 1815. But the cupboard is much older than that, and you can see the under-painted date, 1778, if you look carefully against a glancing light.

My parents bought this cupboard when they were on their honeymoon in Salzburg, from the owner of the Gasthaus in which they stayed. At that time, as often was the case later in their

lives, they had no money at all, so when they fell in love with the blue cupboard they paid for it with 100 light bulbs. I don't know why my father had 100 light bulbs with him on his honeymoon, but he was like that. And when it had travelled from Salzburg to Vienna, and then crossed the Channel to find its place in their final home, an old cottage in Worcestershire, an entire wall had to be removed to get the cupboard in. Of course, no one else remembers this now; there isn't anyone left who was there. To be truthful, I only dimly remember it, and there is certainly no evidence of the event.

My father's room was more or less the most important in the house; he was of the generation that deemed this to be natural. After all, he was called Franz Ferdinand, not exactly a name redolent of New Man. Making his bed was an arcane ritual. The bottom sheet had to be totally smooth, the pillow filled with horsehair carefully settled. (These pillows were incredibly difficult to replace: I once spent a fortune on a new one for him, as a Christmas present. Although this was not as difficult as finding the very unwieldy lavatory paper that he preferred, which on one occasion I was reduced to stealing from the university at which I used to teach.) And then there was the buttoning of the duchend, what we now call a duvet in England. Those old ones that my parents brought with them from Vienna were filled with duck-down, and the buttonholes on the cover, carefully embroidered around the edges, were rather too small, so great patience was needed to button them all up.

Although I must say, perhaps because he did not for a second question his maleness in a male world, my father was never patronising to his family of women, and he expected his

daughters to do something honourable with their lives. Well, maybe honourable is not an exact description, for sometimes we doubted whether, in spite of his considerable intellect, charm and fairly extensive scientific knowledge, he really understood the difference between what was right and what was not quite right. He was a terrific quarreller, and so country life rather suited him: there were always boundary disputes, with fists threatening the air, and lawsuits over rights of way, which he enjoyed hugely and nearly always lost. My mother trembled with fear at the thought of losing her beloved cottage as a result.

My mother used the blue cupboard as it was intended to be used, to store linen. They are still there, gently folded piles of sheets, towels and monogrammed linen table napkins, although she didn't starch the napkins, which is the only domestic chore that I enjoy, apart from cooking: the spraying of the starch and the wonderful stiffening of the fabric under the iron. But come to think of it, there wasn't spray starch in her time; I believe it was made from potatoes then. In her youth, she told us, a seamstress came once a month to their apartment in Vienna and did the mending for the entire household. My mother was delighted with the labour-saving devices that appeared in the 1950s and '60s. Spinach, she said, used to take a whole morning to prepare. Now that you can buy it frozen, she continued, I often hesitate between that and frozen peas, as peas really only take three minutes, whereas spinach might take twice that time. She would recall with amusement and some amazement that when she and my father were first married, and it had taken her and a maid several hours to prepare lunch, he returned home at midday and lovingly asked her, And what has my little darling

been doing with herself all morning? My father sometimes displayed a Panglossian optimism that everything would always arrange itself for the best. He would make appointments weeks ahead to meet someone at, say, the corner of B. Street at 3.45 on Wednesday 19th, and although he never confirmed, he was always there on time, and usually the other person turned up as well. And he only just escaped decapitating me, aged ten, when I was riding on the back of his open truck with my head sticking out and he raced into our corrugated-iron garage at 40 miles per hour. Had I not been paying attention, he would have had to pick up my head, neatly severed from my body and branded with symmetrical serrated markings. Indeed, he once spilled me from my pram while playing a kind of push-and-pull game on a promenade in Orpington, where we lived on first coming to England in 1938. I was brought home howling and bloodied to my appalled mother. I still have the scar on my face, sitting tidily alongside another, also inflicted – inadvertently I have to say – by one of the other men in my life.

The shelves of the blue cupboard are edged with scalloped and embroidered linen. Now rather yellow, the edging has never been washed. Some of the linen stacked in the cupboard belonged to my grandparents, perhaps even my great-grandparents, but most of it has been acquired since the war and is old, but not antique. Some things become old and worn but never achieve the status of antique. But the blue cupboard is antique, and it still stands there. And its blueness cannot really be explained: it is a blue that cannot be reproduced, nor represented in any form other than itself, because it has been painted by time, and the patina of age can be understood only by looking.

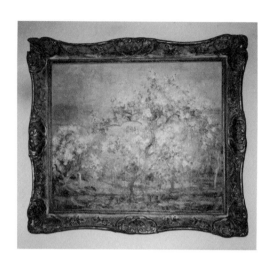

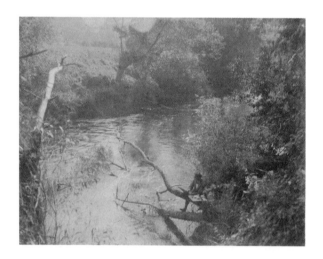

Top: Painting of an apple orchard by H. W. Adams
Below: H. W. Adams sketching by the River Teme

I hardly remember Harry Adams now. He died when I was younger than ten, and had seemed very old indeed, although I recall his fierce vigour. He himself used to tell a story of how, when he was a boy, he met an old man who had witnessed a man being hanged for stealing a sheep. I always imagined the hanging to have taken place on what was then called The Peak, where we children were told a gibbet had been. When I was young this meadow was filled with bluebells and cowslips and autumn crocus, occasionally even a wild orchid, but now it is just used for growing crops. So when Harry Adams cuffed my ear for stealing a blue flower from his garden when I was five, even then I felt this somehow put me in touch with history.

Harry W. Adams was a painter. The W stood for William, and he was known as Billy. At that time the name Billy seemed to carry more gravitas than it does now. He was not just a painter, he was an artist, the real thing, obsessed and obsessive. He went out into the soft landscape of Worcestershire every day of the year, in the rain and the snow and the summer heat. And the landscapes that he painted were exact representations of what he saw: damson trees in blossom, orchards in bud, meadows snowed over, trees trailing at the edge of the River Teme, woods and hedges and vistas. They were the kind of paintings that everyone says they long to have. Why isn't art like that any more? they ask, but they still didn't buy from him once he was past his youth.

By the time Billy came into my parents' lives he must have been resigned to poverty and isolation, as far as such acceptance

is possible. But he had become bitter. And he was bewildered at how he could have turned from a promising young artist with a scholarship to Paris and a painting bought by the Tate into a forgotten man left to teach boys who couldn't have been less interested in him or his subject. Nevertheless, his studio, a wooden shack adjoined to his tiny but exquisite Elizabethan cottage, seemed a magical place to me, stacked high with his portraits of the earth and the sky, and the rich gilt frames that he somehow acquired to put them in. I suppose that is how I first learned what an artist was, and it is possible that I still believe it – that an artist should paint earth and sky – although I have spent a lifetime looking for quite different means of representing the world with paint.

For many years an enormous painting of Billy's hung in the local museum, a red-brick, rather grand, civic Victorian building with very little in it apart from some rock samples and butterflies. There had been a coracle of some antiquity, but when I enquired after it in recent years no one knew its whereabouts. At that time Billy's painting still hung there, next to a Laura Knight, but now that his kind of work is so totally out of fashion it has gone. To the basement? I'll probably never know.

In the dark, blacked-out winter evenings of the war years, Billy often came to our house and the grown-ups played Spillikins, a game in which you throw a pile of finely shaped sticks, which you must then pick up, one by one, without disturbing any of the others. The winner is the person who has removed the most sticks. The game requires a very steady hand. I can't see how I can possibly recall this, but I seem to remember Billy's old and expressive fingers handling the delicate sticks,

which had green and red rings around them, with precision and firm intent. Did he win most often, or am I just imagining that? An aura of importance surrounded the Spillikins table. There were three players: Billy, my mother and my father. Where was Billy's wife Nancy on those evenings? They didn't have children so she would have been free to come too. But she and Billy hated each other with a dark and stoical hatred. They still remained together, as people had to in those days. Small and fine and also an artist, although of course deemed to be less talented than her great husband, perhaps Nancy was relieved to have an evening without him. On one rare occasion when he was obliged to go away for a weekend, she removed all his paintings from the walls and hung her own there until just before his return. I asked her once how a beautiful bowl she possessed had come to have a crack in it. A man did it, she told me. Later it transpired that it was Billy. That is how she thought of him: as a man who cracked the beautiful bowl.

Billy left instructions that his paintings should be destroyed after his death. But they were not. And who can blame Nancy for that? A very hard thing, to burn hundreds of landscapes depicting old Worcestershire, from a time when the county was covered with orchards and meadows, and the scale of the countryside was so intimate, not opened up and tidy as it has become.

Next to the blue cupboard from Salzburg in my father's old room there hangs, still, a Harry W. Adams landscape. It is a picture of an apple orchard in blossom, focusing on the largest tree in the foreground. Who now plays Spillikins, and who, now, dares to paint apple trees in blossom? And who would dare to put it in a gilt frame, the top left-hand corner slightly damaged,

a thing still to be looked at, because somehow, magically, it was painted with love but without sentimentality.

The painting in my father's old room is undated, and unlike so much art it does not declare the time of its making. It is even possible that it was painted during one of the wars, although that part of the country was extraordinarily free from wartime activity; most people remembered suffering mainly from the lack of bananas and ice cream. There were land girls, and there was an Italian POW camp nearby, the inmates of which occasionally helped local farmers on the land. One handsome but mournful Italian – Nastri he was called – took me across the fields every day to catch the bus to the school in the nearest town. In his spare time he and his fellow inmates hunted for wild birds in the hedgerows. There were many in those days: larks, chaffinches, thrushes, robins, wrens, owls, wagtails, hedge sparrows. Only years later, on my first visit to Italy, when I saw the terrible sandwiches piled high in the café windows with little heads falling out at one end and little feet at the other, did I understand what they had been doing.

Harry W. Adams was probably dead when I tasted my first ice cream, after the war. Although by the time I had run the mile from the local shop up the long lane to our house to show my mother this amazing delight, there wasn't much of it left, as it had melted in my hand despite being covered with my handkerchief. After his death Nancy had to live on ten shillings a week, so there wasn't much spare for ice creams for her. It is hard to imagine what would have become of her had my parents not helped out, even in their own straitened circumstances, right up to the end of her life.

So Nancy did not destroy Billy's paintings, and when she died she bequeathed them to my parents. My father was going through one of his frequent financial crises, and they found a local antique dealer (a euphemism, I fear) to buy the pictures as a job lot, apart from a few of the most perfect ones. Fifty pounds of that sale came to me, and with it I bought my first kelim, which set me on a passionate path of collecting, although the flat-weave kelims changed to rugs over the years. Always rather worn, sometimes with holes in, they have provided me with pleasure and colour that is impossible to measure. In a way, I feel that Billy's paintings have been transformed into objects that also rely on relationships both within and without, and that contain their own history, although one that is unfathomable to us in the West – a history of nomadic weavers from mountains and deserts, not one unfolding in the shadow of the Malvern Hills.

Sometime in the 1960s Billy's and Nancy's cottage was sold, and the developers who had sworn to restore it pulled it down. It was replaced by an ugly timber house whose only merit is that it shelters a colony of bats in its rafters. There is new gravel in front, and Nancy's little garden with its tiny topiary has been replaced by a smart suburban driveway.

But the painting of the apple tree in blossom still hangs on the wall in my father's old room.

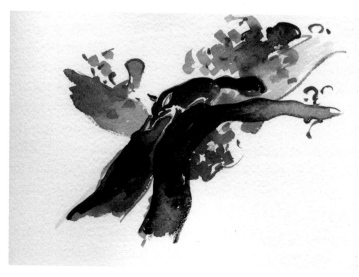

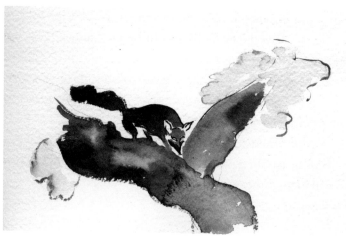

Tess Jaray, *My fox in a tree*

3 . FOX

Last night a fox came into my bedroom. I had opened the French windows to let in some cold air, and was watching Newsnight. Then there she was. I have seen a fox on a misty early morning in the country, and some time ago I saw one drinking out of my birdbath. It's not rare to see foxes in London now, but it must be rare to have one in the bedroom. She lifted her head and we exchanged glances. I saw the unfathomable wildness in her eyes and felt privileged, as though an ancient queen had initiated me into a magic rite. That is what I would like a person to experience when they look at my paintings: an exchange of glances.

She strolled around the room, taking very little interest in me. I, on the contrary, took a great deal of interest in her, not quite understanding that this was to be unrequited love; she never found me to be anything but a convenient landlady. She settled under the shed at the bottom of my garden and produced three cubs of indescribable beauty who ran amok through my vegetables at dawn and cast a spell of enchantment over me. I attempted to draw them, but they didn't remain still for a moment, so the drawings had to be made from memory and imagination. I became obsessed – love does this – and started to make sculptures of them, papier mâché to start with, a bit like returning to nursery school. It didn't for one second bother me, or even occur to me in fact, that these objects were far removed from the paintings that I had been making over a lifetime.

I was happy and absorbed in my work when disturbing news reached me. I thought that I may be obliged to move away from

my peaceful home and garden. The house next door – separated from mine only by a wall – was to be sold to a pop star. Not just any pop star, but one famous for her loud – if wonderful – voice, her uncontrolled behaviour and her drug-addicted husband: Amy Winehouse.

Would the noise be so great that I couldn't work? Would my nights be disturbed by endless parties and music? What about car doors slamming at two in the morning, to say nothing of the paparazzi waiting outside all day long. What should I do? Move? Live with earplugs? Arrange for her to have a baby so that she herself would demand quiet – there were some offers here from my younger friends – or hope that she would turn out to be a sweet person who never made a sound.

None of these things have yet transpired, she hasn't yet moved in, but I built a shed next to the other one, and started working seriously on sculptures, because something had become clear to me: Amy Winehouse looked like a fox. So I had to love her too.

Amy Winehouse did move in. She was a perfect neighbour, and we would wave to each other from our windows. For a brief period I achieved immense status among my friends: Amy Winehouse lived next door. Until that terrible afternoon when I looked out of my studio window and saw an ambulance and people screaming in the street.

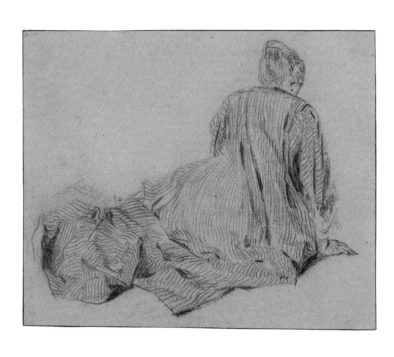

Antoine Watteau, *Woman Seen from the Back Seated on the Ground, Leaning Forward*, c. 1716. Red and black chalk, wash and graphite. British Museum, London

There is a great difference between looking at a painting and looking at a drawing. Perhaps it's like looking at a person dressed in their best clothes, in contrast to how they look when they are wearing nothing. In a painting, artists can separate themselves from the world. Colour, and the *stuff* of paint, are weapons of distancing as well as of enticement, and they are used by artists to give to the world those experiences, thoughts and feelings that they have decided to present. But with a drawing artists are undressed and defenceless. They cannot hide behind a drawing. Drawing is the artist's connection to the world, a way of reaching out. And it cannot be done without expressing something of the spirit.

I thought I knew the work of Watteau. I was familiar with his *fêtes galantes*, the glowing colours of his costumed figures, the air of artifice, frivolity and enjoyment. But behind the gaiety and felicity of his paintings lies something else, something wistful, solitary, mournful. Some artists only connect with the world at a tangent; they do not express who they are, but find in art an ideal that is absent from their own lives. Watteau, who was ugly and his body misshapen – his brutal father saw to that – must have found great comfort and an escape from the harsh reality of his background, and indeed his own solitary and reclusive nature, in depicting the fantasies of his painterly subject-matter. But there we do not find the levity that we see in Fragonard or Boucher. Watteau's spirit of melancholy breaks through in the paintings. It is as though he is being deeply serious about frivolity – for surely an artist of a frivolous nature cannot depict frivolity?

The drawings are different. It has been said that Watteau preferred his drawings to his paintings. He referred to them as his *pensées à la sanguine* – 'thoughts in red chalk' – bound them in albums and kept them for himself. Many artists do the same – they prefer to hold on to their best work, and are happy to let go of the rest. I can understand this.

There are many qualities in Watteau's drawings that could also be attributed to other artists, certainly to his heroes, Titian and especially Rubens. Watteau also used 'earth' materials – in his case only red, black and white chalks, hacked from a lump of rock of a particular density then sharpened and shaved to a point. To me there is something wildly romantic about this: direct, from earth to paper, from heart to hand, to be able to achieve such an incredible immediacy with the material. But there is also much in Watteau that differs from those other masters: there is nothing at all casual in his drawings; they are not sketchy, but instead deliberate in the way they are composed on the paper.

I believe that *Woman Seen from the Back Seated on the Ground, Leaning Forward* is one of the greatest drawings in the pantheon. It is certainly in the private Museum of Great Drawings that I hold in my head. One might ask: what is its subject-matter? The woman is not identified, she is evidently not young, nor is she doing anything in particular. But the drawing holds within it everything that might be asked of a drawing: a balance of simplicity and complexity perfectly expressed. The graceful drapery celebrated with the lightest of touches; the stripes of the gown revealing – so subtly and yet so clearly – the form of the body underneath. Each line, each stripe, glowing, edgy, observed, grounded, yet simultaneously ready to

fly away in its lightness. The power of the shoulders held by the strong arm, the tenderly described delicacy of the supporting hand, show us that he saw no conflict between age and beauty. The shorthand with which the meeting of gown and blouse are described – just the smallest touch of decoration added to set off the simplicity of the whole. Painters always speak about the moment frozen in time. In this drawing you see such moments embodied in opposites: movement and stillness, arrogance and vulnerability, clarity and intimacy.

This drawing might also be read as a kind of landscape. As with Leonardo da Vinci, rivers or tangled weeds may be seen in the cascades of hair, mountainous ground in the trailing cloth of the dress. In Watteau's *Four Studies of a Woman's Head* there are references to animals. The rhythms of nature run through many of these drawings, not only the ones that depict nature itself.

In *Seated Woman* Watteau explores his love of stripes. In some drawings the stripe and the line are the same, that is to say they describe something simultaneously, with great economy. In this drawing the overall shape of the dress is described in red and black chalk – the red sounding the dominant note – which at the same time describes the stripes of the cloth. This drawing is a remarkable demonstration of the power of Watteau's geometry: the dress explodes like a sun, prevented from chaos only by the placing of the hands at the centre; they hold the fold together, so that the centre does hold. This is also one of his most startling drawings in terms of colour. Using only red and black chalk, with not even touches of white, it still gives the impression that he has used every colour in the world. Here you really see his response to the limitation of his materials: the intimacy of the

chalk, its interaction with the texture of the paper, the way the chalk sits on the handmade paper, picking up the minutest detail of any irregularities. The paper lightly catches the pigment, so that everything comes together in a perfect marriage of surface and chalk.

There is not space here to describe the breadth of what Watteau shows us. How in the arabesque known as *The Bower* he arouses all those emotions one feels on looking at heaps of fine lace or bunches of ripe grapes on the vine after rain. Here you feel that pleasure becomes almost an object. How, too, in *Seated Persian Wearing a Turban* the figure's personality is evoked through careful observation and depiction of dress – the artist is saying: see how clothes make the man, how we hide behind externals. How the geometry of heads and hats and hair in some of his studies is frequently so pure that it makes one think of the perfect form of an egg; not just hens' eggs but birds' eggs as well, spheres pointed at one end. Striking, too, in his studies of various ways in which the head sits on the neck, is how he conveys, through line rather than shading, subtle changes of mood.

We cannot know for sure the consequences of Watteau's consumptive illness for his work. But I believe there is a febrile intensity to the quality of his line that might in part be explained by his awareness of the proximity of death. A desire to avoid any approximation of form or subject, to get as close to the thing as possible. No falsity or lying. Nothing ever just for effect.

For a great artist the precise nature of a line is a matter of life or death. The eye and the heart are as one in a drawing in a way that can never be the case with a painting, in which the mind plays a greater part. Or, one might go further and say that the

eye and the heart are bypassed, and through the hand the mark becomes a direct route to the spirit – his particular spirit, which can be explained only by how the mark presents it. Drawing is the connection between an artist and the world. And possibly it also connects artists to each other, as well as to history. After all, we know that drawing has not 'improved' since cave paintings, only that our perception of it has changed over the centuries.

He died on 18 July 1721, aged 36.

First published in RA Magazine, *Spring 2011*

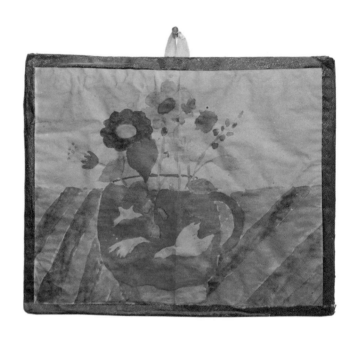

Tess Jaray (aged five), *Still-life with Flowers and Striped Tablecloth*

5. STILL-LIFE WITH FLOWERS AND STRIPED TABLECLOTH

There were three paintings that hung above my mother's bed. They hung there for nearly half a century, and they are still there now, even though the bed is empty. They are watercolours on paper, and the paper is now very yellowed, and they are still framed with 'passe partout', a sticky black tape that was used during the war years. As its name suggests, it was used for everything and anything that needed sticking together. *Still-life with Flowers and Striped Tablecloth* I painted when I was five years old, and the other two are mountain views in Switzerland, painted on our first holiday abroad after the war, when I was nine. We went on one of the rare occasions when my father was in funds.

Those three paintings represent to me almost the sum total of the pictorial problems that I have spent a lifetime working on. The two mountain landscapes presented technical problems, problems of perspective, that most children will face when they try to depict visual reality. The first one was how to make the space slope down and away from the viewer, instead of up and towards you, which is what it looks like when you look at the picture. The second was how to paint the space between the mountain top on which I was sitting with my box of watercolours and the mountain range on the other side of the valley, which was a very long way away. These are interesting problems for a painter, and luckily they may be solved through practice.

The other problem that I faced aged five was not so easily solved. It went like this: I painted the flowers red, blue, yellow,

green and white. They were in a vase, which had a pattern of three white birds on it, the white indicated by the paper left unpainted (rather crafty for five, I now think, and feel sadly that perhaps this was the best painting I ever made). The vase was placed in the middle of the striped tablecloth in the centre of the painting, and I started painting the stripes on the left-hand side of the vase, after which I painted the stripes on the right. When I had finished, I sat back to admire my work and received a horrible surprise. The stripes did not meet up. They had been painted at different angles.

I looked round to see if anyone had noticed this impropriety, this unseemly transgression. No one was there. I looked at the painting again. Was it really so terrible? Perhaps no one would notice? It couldn't be changed; anyone who has ever used watercolours knows that once the paint is there, there it stays. Not for nothing is Cézanne a genius. But I hadn't yet come across his work. So I left it.

Indeed no one ever remarked on it, but the question has remained with me ever since, unresolved. Where does morality lie in art and is there any relation between art and truth? You cannot dissemble in painting. You cannot hide what is fundamental to the spirit of a person. Although it may take some detective work to see it. Secrets lie underneath the overt expression, and sometimes can only be articulated by their opposite. Much of painting is open, there to be seen, all at once, unlike music or literature, which unfolds over time. So it is tempting to think: what you see is what there is. But this is not always the case.

One night, it must have been late 1946 although I cannot be sure, underneath this array of fine art (this is actually not quite

accurate: at that time only *Still-life with Flowers and Striped Tablecloth* was there – the landscapes had not yet been painted), my parents were reunited with two friends from Vienna whom they had not seen since they all escaped from their homeland. E and M had been my mother's soulmates, and the two of them had fled together and found a home and sanctuary in Basel.

I no longer know where I actually was that night. Was I in my bed in the next room, where I slept with my younger sister? Did I listen to the dramas being recounted through the old door, put together in Elizabethan times from planks of oak, that separated our room from our parents'? Or was I, too, taken into the bed, which I hazily recall accommodated all four of them, as they talked endlessly through the night, happy, excited at having found one another again, recounting their flight, wanderings, adventures.

I really don't know how to describe that desperate time of seeking survival. The story of my father's endless wait for emigration papers – before people were allowed to leave the country a thousand forms had to be signed: if you had a dog, you had to swear you had paid the dog licence, if you didn't have a dog, you had to swear you would have paid it if you did have a dog. And how he finally got to the head of the queue: his landlord, Herr Rauch, was a policeman and had pretended to arrest him, marching him up to the front so that he was able to get the papers stamped and his escape made possible.

Twenty years later I was to witness my parents' reunion with the Rauchs in Pötzleinsdorf, just outside Vienna, in the same house where they had their first married home, with its sloping roofs and long path leading to the locked front gate. Frau Rauch,

rotund, as wide as she was high, together with her husband, the ex-policeman, disbelieving and joyful at seeing my parents again. And when they had recovered from the shock of this amazing return, we had tea together, amid the dark and heavy old furniture.

There have been so many similar stories since then – probably they will go on forever – but for me at that time the drama was inexpressible, partly, I think, because so much of my past had not actually been explained. Not until I was sixteen did my mother tell me the truth, feeling that her daughter really should not face the outside world in total ignorance of her history.

So the unfolding of those tales that night was, for me, also an unfolding of my own past, another series of clues on the mysterious trail of discovery. E and M's recollection of the weeks hiding in forests in the south of France, surviving only on chocolate almonds. The periods spent wandering through those southern towns, keeping always on the move. The secret of evading discovery was to go each day to the hairdressers, so that one always looked immaculate, avoiding the desperate and unkempt look of the hunted.

And the final escape: places bought in a tiny rowing boat for two, which had to accommodate twelve, among them a passenger drunk and singing, despite the need for absolute silence, as they crossed Lake Geneva to freedom. Where, eventually, they both married rich Swiss men, who died quite shortly after, and lived out the rest of their lives, to my mother's annoyance, as rich and merry widows.

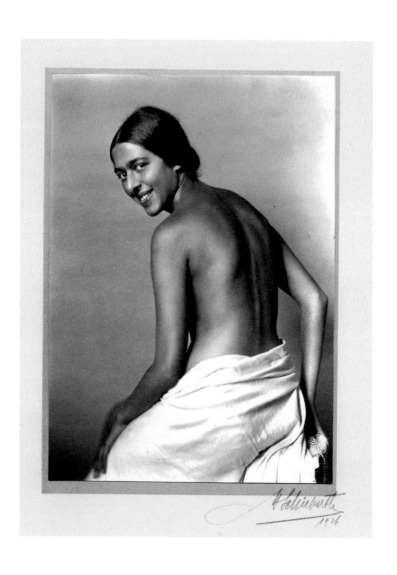

Pauli in Vienna, 1920s

Deep in the wilds of rural Worcestershire, my mother was always perfectly dressed. Never extravagantly, with not the remotest echo of vulgarity, always right for what she was doing. But still, one glance and a person could tell: this was not a native. It did not seem, however, as though she had been transported from the Ringstrasse of Vienna without a change of clothes. They were somehow appropriate to whatever she was doing, but at the same time they bonded with her persona in such a way as to suggest something foreign to the surrounding orchards and meadows. Yet they were complementary, not alien: a counterpoint in harmony.

Her name was Pauli. She was small, very small. When they were first married, my parents had a wooden stool made for her to stand on so that she could kiss my father more easily, for he was very tall. When it fell to pieces over the years, they had a replica made. It is still used in the old cottage as a door stop, but no one uses it for kissing now.

Pauli had shiny black, smooth hair pulled into a bun at the nape of her neck, and huge dark eyes, always spilling over with emotion – fury, amusement, disbelief, love. Even her tenderness was tinged with passion. Her passions were always near the surface. Once, much later in her life, at the doctor's surgery for some minor problem, she stole a glance at the letter her doctor had written to a specialist, and was much mortified, if also amused, to read the description of his patient as a very emotional Continental lady. Oh no, my sister said, when I checked this

story with her, it wasn't quite like that: the doctor had called her an emotional lady from eastern Europe, and my mother was appalled that he didn't know where Vienna was.

So what with my mother's passions and my father's fairly uncontrollable temper, the atmosphere at home could not exactly have been described as tranquil. But what Pauli was doing, mostly, was caring for her family, in the manner in which that was done in the 1940s and '50s, when housework was just that, house work, with the usual postwar shortages, no bathroom in the old house, no running water, and no members of the older generation left to help. But still she was perfectly dressed. Not with an assumed elegance, born of some false idea of how things should be done, but one that quite simply, and mysteriously, emanated from her natural grace.

She made everything herself, indeed was only happy while making something. Of course she made her children's clothes as well, so that anything actually bought still seems to me the height of glamour, and nothing made to measure will ever do for me now. But neither of Pauli's children was ever sent to school with even the tiniest hole in their vests. I was so grateful that by the time my own children were of school age, holes in vests – in anything – not only did not matter, but were more or less obligatory. Pauli made dresses, darned socks (who thinks of doing that now?), mended shirts, knitted sweaters, sewed leather patches on jacket elbows, and repaired sheets and pillow cases (the sort with the embroidery that leaves a pattern imprinted on one's face in the morning). And she kept every scrap of material in an old carved chest in case it might come in useful, which it always did, sooner or later. They were still there when she died,

a palimpsest of fabrics that we still have, a glimpse of which powerfully evokes her presence.

Around five o'clock every afternoon she changed her clothes. This was an unvarying ritual that persisted until almost the end of her life. It may well, in part, account for the durability of her marriage. This ritual involved changing all her clothes. Not just her blouse or skirt, but everything, from head to toe. First, the undies, brought with her from Vienna. Black ones and white ones, they were made of the kind of smooth and fine nylon that lasted forever. Naturally, this is not produced any more; if it were, no one would ever need to replace anything. Oddly enough, my own little undergarments, also brought from Vienna, were made from silk. I still remember the dreadful rustle of static that ran through them as I warmed them in front of the one-bar fire at seven o'clock on cold winter mornings before going to school. My mother's, however, were made from that everlasting nylon and were very loose, a simplified version of French knickers, as they were known for a while. For nearly 60 years, they hung on her washing line several times a week. After each wash they were ironed. Ironed. Is there anyone left who irons undies?

Next in the five o'clock ritual came an elaborate suspension system for keeping up her stockings (always stockings: she never came to terms with tights): clipping and arranging, an orchestration of attachment. Occasionally an item – a cardigan or a pair of gloves – might bear a label saying Made in England. This was always taken as a sign of great superiority, something of which to be very proud. And then, of course, she applied her perfume. I don't remember which she wore in the early days, but later it was Guerlain's Mitsouko. (I absolutely refuse to believe

my granddaughter's tale that this can now be bought in Argos for £20). I still have one of those entrancing old bottles, and it still smells, faintly, very faintly, of my mother.

There was no social life at the end of the long sandy lane where our house stood, alone apart from a few other scattered cottages, all inhabited by the unworldly, who were not given to dropping in on each other. Pauli was not dressing up for anyone else, but because that is what she did. Of course the lane was only sandy in the summer. In the winter it was muddy, and on one memorable occasion, the great freezing winter of 1947, it was so completely snowed over that my parents got their skis out of the barn and skied down to the local shop to fetch provisions. Perhaps the shock waves that this sight sent among their neighbours contributed to the landslide that forever altered the local landscape the following spring.

So when my father came home from work in the evening, my mother bore no traces of cleaning, cooking, washing, ironing, feeding the chickens and, for a while, looking after the geese, goats and pigs, which were kept as much to enliven the hilly landscape as to help with the food shortages. There is a photograph of her in the 1940s milking the goats – no mean feat for someone raised in the cultural vortex of the Austro-Hungarian Empire – in a flowery overall and Wellington boots, a scarf tied around her hair in exactly the right way, because she always knew exactly what the right way was.

Middle-class English ladies, she said at the time, when she had lived in the country for only a few years, seem to have only two topics of conversation: the difficulty of getting good corsets and the difficulty of getting good servants. As she was small and

slim and beautiful, the first didn't interest her, and as there was no money (and she was, anyhow, a good socialist), the second wasn't relevant to her life. So she must have had rather a dull time with those ladies, and sometimes she did indeed come home after an occasion and say, wistfully, Thank goodness I was there to keep myself company: I would have been so bored otherwise.

Her humour was always near the surface, and she was fond of illustrating her conversation with quotes, such as:

O fat white woman whom nobody loves
Why do you walk through the fields in gloves?

Or, perhaps to illustrate the fickleness of love, from Samuel Johnson:

If the man who turnips cries
Cry not when his father dies,
'Tis a proof that he had rather
Have a turnip than his father

And she had a sharp eye for artists repeating themselves, or as she sometimes put it, in the case of Beethoven for instance, stealing from himself again. Is my memory foggy, or did she enjoy the one on the poet as thief?

The poet steals from right and left
The victim looks on quite bereft
The poet takes from left and right
The victim sees it as a slight

And seeks revenge with all his might
Who is this goat who thinks he can
Reduce his stature as a man?
He won't go down without a fight
Be left diminished in his plight
With day turned darkly into night
But if revenge is what you crave
And if indeed you can be brave
Then turn the drama into farce
For upside down his face is arse.

And if this wasn't one of her favourites, it might well have been, for she was partial to being mildly shocking. In her day, profanity surely carried more weight than it does now, and she was certainly not averse to using the German versions, which to me always seem much harsher than the English. For example, the word *Bein* – bone – for leg, or *Fleisch* – flesh – for meat, as in *Schweinefleisch* – pig meat – for pork. As a matter of fact, she always found it a great convenience to be able to swear in German, although this backfired on one occasion, when some smart Austrian friends whom she was trying to impress looked fondly down at me and asked if I too knew German. Oh yes, I grandly replied, and came out with a string of graphic invectives that must have sounded strange from the lips of such a sweet-looking child.

My mother somehow meshed the culture of Vienna and art with the culture of postwar Britain and the countryside of which she was now part. The old was not forgotten or rejected, rather it seemed to colour and enrich what she was now experiencing.

Even surrounded by mud and chickens, with hedgehogs in the kitchen and rats in the shed (we never managed to locate the lethal rat poison that my father bought), art and artists were still a reality to her, a normal part of life. And she was always very aware of the fact that even the greatest artists were human, and given to the usual human failings, whereas my father, I think, felt that the great artist-gods of his youth, such as Goethe and Schiller and Mozart, were quite removed from the human race.

I wonder if her aversion to sentimentality was in some way a part of the radical Viennese modernism that surrounded her while she was growing up. The sentimental art of the Biedermeier period of the previous century had been completely rejected by the artists of her own time, by Klimt and Schiele, Mahler and Bruno Walter, Karl Kraus and Adolf Loos. They wanted art to be free to deal with the fundamentals of expression, to find an authentic language, to go back to basics, as it were, and start afresh. Although today it is hard to grasp the radical nature of Klimt's paintings, for example: with their cascading gold and silver apples and elaborate ornamentation, they appear now as the height of decorativeness. But when they were made, their ornamentation and stylisation seemed almost abstract, and the simplification of his forms and figures a daring leap forward into the new century. Perhaps his huge success on all sides was to do with the fact that the pill of abstraction was so heavily sweetened.

Or was my mother wary of sentimentality because she believed – as I think she did – that where there is sentimentality, cruelty is usually lurking nearby?

As far as teaching us children anything, it was as if the educational process had gone into reverse. Her method seemed

to be: what could she learn from us? In fact, she was never really concerned to teach us much at all, expecting, perhaps, that it would happen organically, by osmosis. She may have been right: educated at school as proper, well-mannered English children, we probably learned to deal with the world in ways she couldn't know about.

She bequeathed some things to me for which I am deeply grateful. Here in England, it seems, we don't have much fantastical mythology, so without her I would have missed the absurd pleasure of bowing three times to the new moon (thirteen times if you have the misfortune to see it through glass), believing that a spider seen after noon is lucky and, naturally, never walking under a ladder. I had to draw the line, however, when I started to file my nails while sitting with her one afternoon and she cried, quite shocked: Not on a Friday! But it was too late: she should have explained the dangers of filing your nails on a Friday (on a Sunday as well, apparently) when I was young, so that I could have taken on their significance.

Her nesting and survival instincts were very strong, because in spite of being so intensely emotional by nature, she made no fuss about all the hard physical work she had to do, and never really bothered to teach us children how to do much of it. She disliked cooking, but the Daily Miracle, as she called it, during the rationing years of the war and afterwards, meant that there was always something nourishing for dinner. Like nearly all her generation, she remained incapable of throwing away even the smallest amount of food, and was really only satisfied if at the end of a meal there were just two carrots left. These were carefully kept back to form the basis of the next day's meal.

Later, after rationing ended (although for many years the weekly box of groceries was termed the Rations), some of Austria's culinary greatness appeared on the table. A pale yellow *Gugelhupf* for tea, a cake made with yeast in a special circular, ridged baking tin. *Reisauflauf*, a kind of rice soufflé, also pale yellow, with lemon and full of sultanas, which you were supposed to eat with raspberry juice, but that didn't exist then, so we had Ribena instead. *Rindfleisch*: beef, boiled and served with fried potatoes and tomato sauce (it was explained, every single time we had it, that the old Emperor Franz Joseph ate only the soup in which the beef was cooked and his poor servants were left with the meat). And, to get my father into a state of high excitement, *Marillenknödel*, sweet dumplings made with potato flour, rolled out and shaped into squares with an apricot and a lump of sugar tucked in the centre. A huge bother, they had to be boiled, then drained, fried in butter and breadcrumbs, and finally dusted with sugar and cinnamon. The sweet softness of the dough and the tart sharpness of the hidden apricot must have seemed to my father to encompass in one spoonful all that was gastronomically glorious from his youth.

During the war, of course, we ate the same dreary food as everyone else, although I do remember one particular horror, a sort of Wiener Schnitzel made with cheese (at the time it was called Mousetrap, which tasted slightly mouldy) and dripping with grease. On occasion, however, there were special treats, and during the times that my parents kept poultry and goats we were sometimes obliged to eat them. I mourned Jennifer most. I no longer remember which of my parents cruelly told me, after I had so enjoyed the famous Viennese *Backhändel* – fried chicken

in breadcrumbs, no relation whatsoever to the deep-fried cotton wool that now passes for food – that I had just devoured my brown feathered friend. My father was in a state of shock, having been obliged to wring her neck. I still remember clearly his face turning a ghostly white. There hadn't been many opportunities to practise this at his grand home on the Prinz Eugen Strasse in Vienna.

There was one vegetable that was readily available but never on our table: swede, on which my father, along with thousands of others, had been forced to survive during the First World War, when Austrians were starving. Even Franz Joseph had been obliged to allow his favourite white Lipizzaner stallion to draw a milk cart in 1915, a year before his death, to demonstrate that he was at one with his beleaguered citizens. For six months, my father used to say, they had nothing to eat but swedes, although they were always served on beautiful monogrammed plates with a delicate scalloped black and red border. My parents somehow managed to bring these plates with them to England: they are still stacked in the polished Welsh dresser that sits in their old living room.

Just after the First World War, Pauli was helped by the Dutch, who, true to their humanitarian tradition, offered homes to the starving children of Austria. She was part of this scheme, but when she arrived in Holland, aged about fourteen, her name could not be found on the list. Left standing alone until all the other children had been collected, she was then taken into the family of the head of the organisation. She stayed with them for nearly a year, gained weight, learned to speak Dutch and remained in touch with them for the rest of her life. Unfortunately I do not

know the identity of these ministering angels. When I called the Netherlands Embassy I was told to look it up on the internet.

The fact that my mother's sartorial perfection was unusual didn't occur to me until she was very old indeed, over ninety, and had just started to lose her beauty. On one occasion we took her to a local village fête in her wheelchair. Suddenly I saw this exquisitely dressed person in relation to the other villagers. She looked as though from another world, wearing a neat, crisp blue linen dress, no collar – collars were not in fashion that year – and of course shoes to match. She was always greeted with friendliness and kindness, and everyone pretended not to notice how different she was. I also must have assumed, in some strange way, that all mothers had a ship's trunk in their room, marked with the family initials, full of 1920s chiffon dresses and embossed shoes, the shoes sadly of no use to me: she had such tiny feet.

When we children were young, I'm not sure that she was aware of how different she seemed to other girls' mothers, of her 'foreignness', as my rather snobbish little school friends thought of it. (My father certainly saw himself as the perfect English Gentleman, not acknowledging the strong accent that never left him.) And neither parent understood the absolute necessity for invisibility at school events. Every child lives in dread of their parents' conspicuousness. I approached speech days and carol services with particular apprehension, certain that they would do something shameful. There was one episode when I was not wrong. I was about ten years old, sitting at the back of the hall, partly hidden by some older girls and partly by the piano. My parents entered, keen to see their daughter, by now almost completely English, accustomed to this new way of life. At that time the New

Look was sweeping the country, like no fashion before or since – relief at shedding war-time restrictions was palpable – and my mother came in wearing a flowing green dress with white spots. (This fabric was to reappear as cushions, and again, when we tried to find some occupation for her old hands in her final years, as squares for a quilt, which she worked on even in her nineties by getting down on her hands and knees and pinning on the floor.) And in what manner did my parents shame me, in front of my important little friends? These were good daughters of the local bourgeoisie: lawyers' daughters, shopkeepers' daughters, but mostly farmers' daughters, all with a beady eye for the class status that was of such desperate importance at that time. In the middle of that sea of parents, who were all seated and understood perfectly the need for respectable anonymity and sensible conformity, mine stood up, visible to everyone, in order to make certain it really was their daughter cowering there, attempting to make herself disappear. Meaningful glances were exchanged between the other girls.

Clearly I have never recovered from this public humiliation or I wouldn't be writing about it now. And I have always scrupulously obeyed my own children's orders, at their school events, to look as drab and dreary and anonymous as possible.

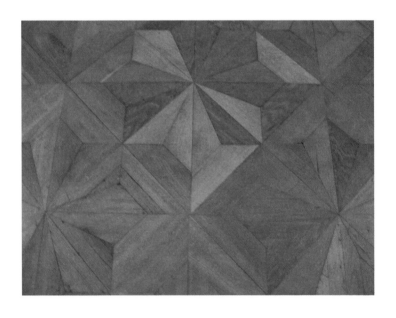

A floor in Vienna

There are about eight rooms in the apartment. Fairly small as rooms go in that part of old Vienna. A combination of intimacy and formality, beautifully set up for the life of work and family, which he always said were the most important things. What place love and war had in this hierarchy I'm not certain. And the apartment is full of fascinating things that draw people from all over the world. They peer into the glass vitrines, gaze at photographs that seem to reveal so well a particular moment in history, perhaps even looking out of the rather fine triple-glazed windows at the evocative surroundings, and they buy postcards of the famous couch (which is actually in London).

But never have I heard mention of the floors. Pale old wood, its honey colour made only slightly deeper by the patina of time, laid in differing geometric patterns of parquet. Not very complicated, not like those in the great palaces all over Austria, or France for that matter. In England we have always had wonderful timber, and often wonderful floors, but we never went in for the complex patterns that were the fashion on the Continent in the eighteenth and nineteenth centuries. In the museum that was his apartment some of the floors are laid in the simplest of herringbone patterns, but always edged so as to give a sense of completeness to each room. In all cases the scale relates perfectly to the human body, properly containing those who stand or sit in the room, or walk across it. This must have been a reassurance for him, perhaps even for his patients, but I suspect it was unconscious.

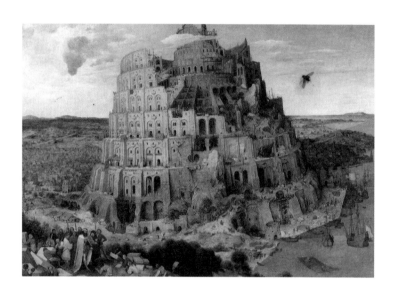

Brueghel, *The Tower of Babel*

8 . BRUEGHEL

My granddaughter Nell and I returned from Vienna last week-end. On the plane I took out some postcards of the Brueghels I'd taken her to see. Among other things of course: her first glimpse of the Secession Building; Vermeer's *Artist in His Studio* in the Kunsthistorisches Museum, and the first truly Gothic experience she's had, in the Stephansdom. Looking at the postcard of Brueghel's *Tower of Babel*, I was surprised to see a bird winging through the sky. I hadn't remembered it. But here it was, such a dominant feature – like one of those details that are always being reproduced. I touched it, as though to understand how I had missed it before. And it came off, for it was just a tiny insect that had got pressed on that spot.

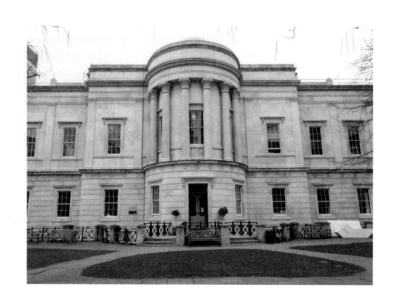

The façade of the Slade School of Fine Art, UCL

In 1957 London was still a postwar city. Piles of fallen houses were part of the landscape, and the landscape itself around University College, of which the Slade School of Fine Art was the left wing, belonged more to the Bloomsbury of the 1920s and '30s than the freedom of the 1960s, which was inconceivable then. We were younger in age than students are now – at least the girls were, many of the boys had spent two years doing National Service – and our sense of the excitement and sophistication of the city would be hard to grasp for the current generation of students, accustomed as they are to media images of our instantly glamorous Western world. Those were the days, after all, when coke was something you burned to keep warm. Although National Service had given most of the boys some (probably much needed) maturity, and the young grew up fairly fast then – we weren't to know that we had long lives ahead of us.

But for a student at that time, life was not really so different from that of the late 1930s, in spite of the socialist reforms made by the 1945 government, which perhaps only started to be understood (and taken for granted) in the 1960s. And, as has often been said, that decade didn't properly start until 1963. For example, food was still institutional: Elizabeth David had only just started her glorious work, more radical than that of any of the eccentric foodies to whom we have now become accustomed. And perhaps it is worth mentioning that money was never mentioned. No one had any, so what was there to discuss? The Slade seemed to be a wonderfully classless society

– grants brought in by the Attlee government made it possible for almost anyone to get a free higher education. Many had to work to earn in the holidays, but even so, this opportunity hadn't existed before the war.

Modernism was starting to wear thin, until it was thoughtlessly retrieved in the disastrous building phase that swept the country in the early 1960s. The vast number of red-brick Lego houses had not yet been built, and looking back at them now, 1950s council houses held a certain charm: slightly pitched roofs, brick detailing here and there. This was a problem that had to wait nearly 50 years to be addressed. Bomb sites were then part of London's landscape; now that the reality of air raids was fading in the public's consciousness, these ruins even had a certain glamour about them, a natural home for buddleia and small boys.

When I started at the Slade, the students would be at work by half past nine in the morning – unlike now – and didn't take their first break until eleven, when we had what passed for coffee. (Like so many of my contemporaries, I didn't have my first real coffee until I was on a scholarship in Italy. I drank this new potion on the Piazza del Campo in Siena, and have been trying to replicate it ever since.) We often sat in some kind of shed (much of the teaching was done in sheds then) and listened to Mario Dubsky and Patrick Procktor compare their theatrical experiences of the night before. Neither we nor Mario himself realised that he was gay – that was hidden from our naïve eyes – but there could not have been any doubt about Patrick. Most of us entered the Slade as singles and emerged three years later as doubles. Some, astonishingly, have succeeded in remaining so.

When I travelled in the holidays with my student husband-to-be, I had to wear a wedding ring from Woolworths, otherwise we couldn't have shared a hotel room, even in the cheapest and most miserable of places. We were, the majority of us, not just naive, but truly innocent, although simultaneously mature enough, having lived through a war, not to have to prove it through obligatory drunkenness. That is why the 1960s were such a shock to some, and so liberating to others. The 1950s were pretty limiting, particularly for women, who were being forced back into convention after their brief independence during the war.

At lunchtime we went to a caff called the Hall of Mirrors and had something called Vienna Steak – mince patties with boiled potatoes – for three shillings and sixpence. Mario, Yolanda Sonnabend, Michael Sandle (dressed in black, then as now, except then it was from motorbike oil and litho ink) and Janet Dawson, his exquisite and talented girlfriend, also my closest friend, who soon after returned to Australia, married a celebrity chef and grew in sympathy with him until she approached his 26 stone. She made a successful career for herself there. Twenty years later we met again on my only trip to the Antipodes, and were still happy to see each other. It was the only time in my life that I have felt ashamed to be thin: she wore her body with such pleasure.

The studios were divided up according to interests. The so-called Slade Painters worked with the greatest possible intensity in the Life Room – long gone from most art schools now, I believe – and were almost without exception followers of William Coldstream, who was then Professor. You painted what was in front of you; nothing else was needed. If you were

really serious and committed, there was a small room in which a model posed every day for six weeks. I never attempted that. The model I remember best was the flame-haired Monica, who had the whitest and most beautifully female body I have ever seen. Later she married Coldstream, but only after he had taken a term off to sort out the turbulence that their relationship created. The marriage didn't last, although he adored the three children it produced, and was often to be seen in the Slade office – the centre of all social activity and gossip – exhausted and complaining about how long it took him to find a suitable pair of shoes for his eldest son. The most spectacular studio was probably the one run by Frank Auerbach, in the tradition of David Bomberg, in which the air was dense with the charcoal they used in an attempt to understand and represent the solidity of space, a challenge to which Bomberg had dedicated himself.

In my first year there remained a space for those who wanted to work from casts and still-lifes. Downstairs there were also rooms in which the life classes were separated by gender, and even the model's breaks were staggered, so that – God forbid – scantily dressed men and women didn't meet each other. But by the time I had been there a year or two, the American Abstract Expressionists had swept the country in a great wave of newness. Almost all working artists of whatever age were deeply affected by the exhibitions of American art at the Tate in 1956 and 1959. And by Bryan Robertson's marvellous curating (although then that word mostly referred to what the guards in public galleries did) of paintings by Pollock, Rothko and others at the Whitechapel Gallery. The phrase that we students used, thinking we were incredibly perceptive, was 'expanding space'. In

other words, the canvas was no longer something to be looked into, like a window, but instead something to be absorbed, to surround us. This way of working required a great deal of paint, which didn't always sit well with our attempts to be true to traditional methods and make our own with dry pigments and a pestle and mortar. On one occasion my husband-to-be Marc Vaux spent an entire morning patiently mixing, grinding, adding linseed oil, more mixing, more grinding, until finally at the end of several hours he had a neat heap of mixed paint. He then used it, à la Willem de Kooning, and with one sweep of his palette knife blew his morning's work.

They were originals, those contemporaries of mine. We took art very seriously. We believed that it was the noblest way of life you could choose. We were ambitious, but for our work, not for careers. Very few students even imagined they would have careers, certainly not in the way that is understood now. (In his address to new students, Coldstream told us we would be wise to leave immediately and get proper jobs, as bus conductors or seamstresses.) There were a few exceptions: the worldly-wise Ron Kitaj, for instance, although he was both some five years older than the rest of us and at the Royal College of Art, which had always been more commercially focused than the Slade. However, many of my generation have spent their lives as artists, a number of them successfully. Six of my contemporaries are now Royal Academicians – all men, apart from myself. Happily, this ratio is starting to change, although it may be some time until there is a proper balance of gender.

We were all very important to each other, and didn't take much notice of our tutors. Tutorials were held three times a

term, lasted for about twenty minutes, and only later became so-called 'deep structured conversations' (I think it was Peter de Francia, who taught at the Royal College, who coined this great phrase). Never again would our work get so much attention, but of course we didn't know this. My tutor was Andrew Forge, but I didn't appreciate his wonderful critical abilities until I left, after which it was too late. I still remember his very first words to me, when I was nineteen: 'The problem with painting', he said, 'is knowing what to paint.' Much truth in that.

Our generation caught the last year of art-history lectures by the great Ernst Gombrich. I learned later that his father had been my father's guardian in Vienna, after my grandfather died in the Spanish 'Flu pandemic of 1918, but I never met him. And we were also lectured to, sadly only once, by Anthony Blunt, on Poussin of course. He took wicked pleasure in referring several times to 'the priapic'. Afterwards we had to go and look up what it meant.

All these things made a powerful impression on me: my fellow students, the introduction to the world of art, the opportunity to develop and understand the subject, the nature of art-passion, which lasts a lifetime. But perhaps what I remember most was the building itself. The soot-encrusted black exterior, classic neoclassical, those glorious high-ceilinged white-painted studios, the mysteries of the sculpture department in the basement, the grinding of the litho and etching plates in the print studios, the occasional great works of art on the walls, such as the Giacometti drawing, long since removed (I wonder who had the foresight and the nerve to take it?). The wide stone steps to the entrance: old, worn, gently rounded, leading straight

ahead of you and then dividing to right and left, they still carry the ghostly tread of the myriad students who have climbed them and – impossibly wonderful – of those who still do.

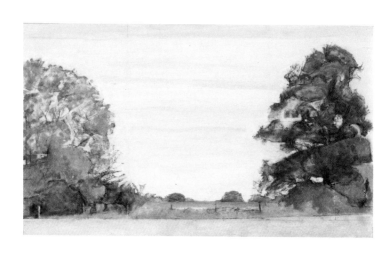

Patrick George, *U*, 2003. Oil on canvas

The trees are exactly that kind of green. The sky is just that kind of sky – dull, promising rain but not quite delivering. The leaves are as you see them. The earth is just *there*. None of this is romanticised. It is not *expressed*. I'm not sure that it is even expressive. It is simply as it is. The English landscape at its most modest, most understated, with its fine misty relationships not really celebrated, certainly not dramatised. But there, nonetheless, as we see it if we are lucky enough to be in it. This is not English boastfulness, not landscape painting competing with vistas of Mont Blanc, nor with the inner or outer turmoil of Turner or Constable, but evoking the bits between.

Perhaps this sounds as though I am defining Patrick George's paintings by what they don't do. Not like this, not like that. But has anyone else – in recent years – done it this way? Perhaps artists have been too nervous of 'Englishness', whatever that may be, fearful of the provincialism and escapism of depicting nature, after the terrible realities of the twentieth century.

Oddly, it is widely held that the English landscape is what the English do best. Very few people who grow up surrounded by it will feel that the Swiss Alps, the Arabian Desert or the Mediterranean are superior. Even those who grew up in English cities – I say English, rather than British, as Wales and Scotland are a different story – usually feel that there is something special, something particular, about their native landscape. And it might be argued that gardening is our national pastime.

So it seems strange to me that we have produced, or rather that we celebrate, so few great landscape artists. We have Turner and Constable, and watercolourists such as John Sell Cotman, Richard Wilson, Samuel Palmer, John Crome and, later, Paul Nash. But we know that even for Gainsborough his love of the English landscape could generally only be expressed in the backgrounds for his sitters. If you look closely at his *Mr and Mrs Andrews*, for instance, it is the landscape that speaks with the greatest passion. The corn, the trees, the sky: he loved them more than he loved the haughty pair. (It is interesting that Patrick George has used exactly the same green as Gainsborough.) There was no market for Gainsborough's landscapes. And one might well wonder how many more landscape artists have simply gone unrecognised, have never been in fashion.

There are many amateur painters who are clearly very happy when they are sitting surrounded by nature and copying it. But it is often easy to see projected in the work of both Turner and Constable their own inner turmoil, as much as their actual subject-matter. This doesn't diminish their greatness of course, but it does beg the question: where are the artists who have depicted our own landscape *as it is*? Is it possible that when, after 1550, religious subject-matter was forbidden, painting went partly 'underground', as art was not considered suitable for churches?

Beauty in nature is not generally considered a legitimate aim in the arts, although there is much evidence, among poets and writers in particular, that this is starting to change. But still, if it's possible to communicate a likeness of our underground car parks or roads through council estates – our landscape now, and

very much of the moment – why not rolling fields or apple trees in blossom? As a subject for painting, landscape is not really acknowledged. After the end of the nineteenth century it seems slowly to have petered out.

Maybe Patrick George has not been working at quite the right time for his particular vision to be understood, although his work could never be mistaken for having been painted at any other point than the present. It is more likely that our contemporary cultural interests are skewed. This is not the place, nor am I qualified, to go into why the English, or the British, have not taken into their hearts their own landscape artists, in spite of pretending the contrary. Perhaps our age is too impatient to perceive the subtlety of George's paintings. They are not declamatory, they might even be seen to be 'well mannered' – surely the worst insult for a painter today. But they do something else: they speak about something between the paint and the landscape. They mediate. So, 'well mannered' in his work means something different: it means allowing the thing to be itself, without any appearance of the artist having imposed his will on it.

This suggests a system of values, but one that our times do not seek. The aggression, the protest, of so much contemporary imagery seems to suffice. No one looks to art for moral or ethical direction. And yet, in Patrick George's work, in his fidelity to the thing in front of him, in the time he spends adjusting his viewpoint so that it is exact, in the precision of a mark, even when that means imprecision, we feel that a kind of morality is confronting us. He appears to be disposed to the truth.

Of course, underlying this is something else, something timeless and mysterious: geometry, and a sense of proportion.

Patrick George says that he comes from the tradition of what he calls 'Coldstream's literalism'. This may be true, but perhaps it is rather that he is by nature inclined to the orderly, the measured and the proportional. And therefore that the William Coldstream approach, which was presented to him at his most impressionable age, as a young student in search of a way to paint, was the method closest to his inclinations. The remarkable thing about his work is that the element of measurement, the impeccable sense of proportion, however much derived – intuitively – from classical ideals, is in no way apparent. When you look at his paintings you simply don't think in those terms, because their structure is so hidden that you feel they have made themselves.

For someone like myself, whose childhood years were spent in one of the wildest parts of the English countryside, Patrick George's paintings resonate with the reality of seasonal moments – the greys and browns of February, the greens of trees in May – and the stretching of space between trees in the foreground and trees in the far distance. His identification with the land and the landscape is so strong that it must surely, in some human way, touch even those who have never known them well.

The spirit of calmness that these paintings convey is a little surprising, when you look at them closely. Not only is there no false mistiness or contrived harmony, but the range of tones is remarkably wide; within the same painting they may go from white to nearly black, yet the drama is restrained, almost hidden. The relationships are so subtly worked, with such an apparent lightness of touch, that you notice them no more than you might when walking down the street. Everything is unified, in spite of

the fact that within the same painting, *Two Poplars 2002* for instance, there are areas of paint applied softly, tenderly, that seem to stand in direct opposition to the parts painted with an almost raw scratchiness.

Patrick George doesn't flatter. He understands that no painted landscape can compete with the real thing. He doesn't attempt this. He paints what is in front of him as he sees it. I believe this is also as it is, but he doesn't claim this. His paintings are so like their subjects, but without the appearance of copying. He has accepted that the English landscape is so perfect in its diversity that to attempt to represent its beauty is a challenge that cannot be met. Maria Callas once said that all you have to do to get a performance right is 'listen to the music'. This is what Patrick George has done with the landscape. His paintings have an inevitability; their power is their lack of narrative.

He has made the places that he paints his own. In the same way that Stubbs made horses his own, or Nash the torn shapes of war, or Turner sunsets, through identification with the subject Patrick George has made the fields and the trees and the skies of Suffolk his own. And although it may forever be associated with the Euston Road School of painting, his work betrays a lyrical love for his place that actually distances him from this association. His paintings suggest an identification with place that is total, that cannot be separated from his love of it. That place is depicted with no pretence, no affectation, but simply the truth, an approach that might come from the quintessentially English tradition of 'plain speaking'.

Looking at his work, you feel that the subject is *as it is*, but also more than this. For the experience is not the same as being

surrounded by the actual landscape, and offers something else in place of that: an illusion, a suggestion that the actual can be transferred onto canvas, and in this way given back to the viewer.

Not all painters achieve maturity in later years. Patrick George, however, has achieved in his maturity a complete fulfilment of his life's work. He is truly at one with the ever-changing appearance of nature.

First published as the introduction to the catalogue for 'Patrick George' at Browse & Darby, London, February 2013

Tess Jaray, Drawing for *Drop*, 2008

In these drawings absolutely nothing is repeated. Every single shape after the first line is different, within its context, until the shapes stabilise, and then they are allowed to repeat, up to a point, which is determined by a very simple measurement, the diagonal of the square, which is the upper part of the image. This is probably not exactly the golden section, but close. In any case, the golden section may be used fairly approximately. It is satisfying when such things appear of their own accord; I wouldn't dream of inserting a golden section proportion – it would seem so contrived and academic – but when it happens independently there is that sense of inevitability that one is always searching for.

I've just looked out of the window and it is snowing. Weather embodies change more than anything else except life itself. Snow falling, so quietly and slowly that you can see each flake on its own, and then settling briefly on the ground before melting. Well, that is what I am trying to do, to catch and hold it that fraction of a second before it melts. Some other kinds of weather would do, rain for example, slow or light or heavy, but only if it comes down vertically (Rousseau did it so wonderfully on the diagonal). A hailstorm wouldn't do. Not climate, but weather: the marvellous subtleties that we experience in England. It doesn't apply to other places, to deserts or mountains, where one thinks of air rather than weather. It must be the soft, rather delicate changes to which we are accustomed in this country.

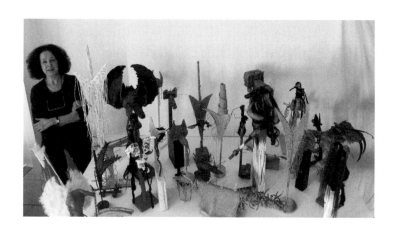

Tess Jaray with her fox sculptures

12.FOX FANTASIES

Chaos, carnage and catastrophe. The foxes got into my precious vegetables. Flattened cabbage, torn sweetcorn, ravaged beans. Such a sad sight first thing on a misty morning in August. Perhaps they saw something moving among the leaves and leapt on to the netting, not seeing that it was there. But I must be philosophical about this, as I love the foxes so much. After all, it would have been much worse if I kept chickens. Now I sometimes dream about the foxes, although it never seems to be those I know; in my dreams they are quite different, not so exquisite, and I see them in the front garden rather than the back, where they live in a hole under the shed.

Twice a week, on Wednesdays and Saturdays, I leave food out for them. They make it fairly clear what they like and don't like. Raw chicken is good, mince shaped into a proper uncooked hamburger shape is good, but tinned dog food is sometimes rejected. As for foxes being omnivorous, all fruits or vegetables are dismissed, even melon rinds, which cats are supposed to love. So this week I was very disconcerted, not to say unhappy, when I saw that a large chicken leg (not organic – shame on me) had been discarded. Had they gone? Been run over? Had another creature – the ugly black tom cat from next door, for instance – eaten the second leg? Or perhaps they had been frightened off in the middle of dinner. I can't tell, for they are in their hole, and I don't even know how deep it is, how they go in and out, or where they leave the garden to hunt and mate and roam. What do they do down there in their hole? We are so far from understanding

wild creatures; we haven't a clue how they really are. Not like cats and dogs, so clearly either hungry or bored, manipulating or beseeching us. But then today, when I was in the garden momentarily without being seen, out came a creature whom I can only describe as Marilyn Monroe: blonde body, dazzling white-tipped tail, sashaying through the vegetables. Oh happy day.

She comes fairly frequently now. Sometimes it's when I'm watching Newsnight, and I wonder if she thinks Jeremy Paxman is also a fox. He does rather look like one. I read *Lady into Fox* by David Garnett, an enchanting story of a man whose adored wife turns into a fox. He discovers that she loves grapes so he has them sent down from London every day, and she eats them most delicately with her paws. (Actually aren't they called pads?) I have been putting out grapes every night, but they are still there in the morning. I dreamt that I saw Marilyn, my fox, in the front garden, looking very fierce, and she made a huge leap up into the air and over the house, landing in the back garden, where she devoured the grapes with pleasure.

A black square

We spend so much time looking and so little time seeing that what an image must do is force one to look, to really look, to try to discern the minute movements that make up the whole, and in themselves add up to a kind of object. How exactly one demands this focus I don't know, but perhaps that is partly the role of colour, and of scale and size, which makes it sound very formalistic. Form in itself obliges certain physical and emotional responses. Sometimes it is dismissed as being of no importance. But I don't believe that, because surely the dimensions of our lives – the pace as we move through a day from morning to night, the spaces we keep between us to attract or resist each other, the rhythms of our heartbeat, the instincts that keep us going and shape us, the reach between birth and death – surely these markers are formal. So in an image in which a particular form is repeated and repeated but slowly changed along the way and finally brought to rest, and one is able to believe in that point of rest, form becomes a metaphor of a kind, even if one can't say precisely what that metaphor is.

My father Franz Ferdinand

My father was not an easy husband. It would probably never have occurred to him to propose marriage to my mother, so she was obliged to give him an ultimatum: marry me or I will leave you. This did the trick, and both families were ecstatic. When my mother went for a celebratory dinner with Emma, her mother-in-law to be, she was made to open her napkin, around which she found a bracelet. This exquisite object was made of fine gold, with an incredibly delicate gold safety chain, tiny inset diamonds, and a four-leaf clover of the milkiest opals in the centre, reflecting all the colours of the spectrum. Blues, greens, reds, yellows, all with that pearly lustre that makes you feel as though the colours emanate from inside the stones. The bracelet is still in its original blue satin box, with an engraved clasp, although by now the box is rather frayed at the edges. Whenever my eldest daughter sees it, her eyes glow with longing, but she will have to wait for this, until I too am dead. I wear it whenever there is an occasion to honour, or sometimes just to give myself courage.

On one unforgettable evening in the late 1980s, my mother got us all together, all the women of the family, aged between fifteen and fifty, and gave away her jewels. They are no use to me any longer, she said, and in any case there aren't very many. Most were left in Vienna with her parents. She wanted us to have what remained. And by some unspoken agreement, or perhaps just luck, we all got the pieces for which we had secretly longed. I received the opal bracelet from Emma and a diamond brooch from my maternal grandmother Helene, my sister was given the

ring that went with the opal bracelet and a pendant that had once been an earring, and my daughters a string of seed pearls and two coral rings.

My father would have approved. He had an eye for the luxuries of life, although he mostly had to do without them. Nevertheless, right up until the disappointments of old age, he remained convinced that in two years' time one of the various patents for industrial inventions that he had lodged with the Patent Office would make his fortune. So perhaps he didn't mind so much about missing out on luxuries: all his adult life he was to be rich in two years' time. This could be cheering, but it also tested my mother's patience beyond endurance.

There was the time, for instance, when he started collecting half-crowns. They were just about to be taken out of circulation and he decided that the nickel-value of the half-crown was greater than either the silver-value or the monetary value of two shillings and sixpence. The entire family was drawn into this scheme, rushing from shop to shop exchanging notes for half-crowns, carrying heavy money bags around with us. Eventually we collected the amount that my father deemed necessary: three thousand pounds' worth, I seem to recall. He then built a small kiln in the glass-walled and glass-roofed room that had been my painting studio. My mother had always loved to sit in there, to enjoy the warmth of the sun through the glass and gaze out at the rich green of the garden while she was sewing. And there, all that summer, one of the hottest on record, my father burned – fired is probably the correct word, but under the circumstances I think burned is more appropriate – his half-crowns, in the hope of making a killing and beating the government.

My mother got crosser and crosser. Hurry up, she told him, I can't stand the smell, the summer is passing, and I will hardly have sat in my lovely garden room. All the while, small, rather mean-looking, dirty grey bricks were piling up in the corner. Soon there was quite a large pile, but the kiln continued to smoke and my mother finally lost her temper. Alright, said my father, I expect they are all done by now, I will dismantle the kiln. The bricks were packed up and shipped off to wherever they had to go to be sold. But the next stage was a catastrophe. The half-crowns had not quite melted and traces of metal were discovered inside the dirty grey metal bricks, entirely due, my father claimed, to my mother hurrying him. He was charged with defacing coins of the realm, a crime that did not carry a prison sentence, but did come with a heavy fine – not to mention the loss of three thousand pounds' worth of half-crowns and a considerable amount of dignity.

Some of my father's inventions were more practical and successful. For example, he didn't like to use the normal soft face flannels that everyone else used, so he bought a ball of string and asked my mother to knit him a flannel of the correct hardness, which was replaced every year, often as a birthday present. And when they first moved to their little cottage in 1942, just before my sister was born, there was only an old pump to provide water. So he designed another that pumped water from the river, which ran far below in the valley, and it served them until they managed to get the mains laid, many years later.

There was also the wonderful contraption that he devised for keeping the birds away from the cherry trees. Morello cherries, which make the best jam and the best puddings, deep red, deep tasting, so sharp in flavour they are almost bitter. My

father adored them. Year after year we watched them ripen and carefully guarded them from attack. As the dawn broke on the day in early summer when the cherries were ready, perfect for picking and eating, the birds swooped down and picked the trees clean. The fury and disappointment can be imagined. So Franz designed a bird-scarer. It had a small engine, which at irregular intervals shook a string attached to the trees, on which were fastened flapping objects – pieces of silver foil, tin cans, things that made noise. This was tremendously successful, although it made an unearthly racket, and woke everyone up at 4.30 in the morning, but it did the trick: the birds were scared off and the cherries were harvested. It was more or less a full-time occupation to keep this machine working, so in terms of the cost in man hours we might as well have been harvesting caviar. But every year, so long as my father had the time and inclination to work the bird-scarer, we had a chocolate cake studded with Morello cherries, which I hold to be one of the Great Cakes of the World.

Some of his inventions were before their time and got him nowhere. For example, the black plastic so familiar to us now, that he developed some ten years too soon. Other people have probably done rather well out of this product, but this is no doubt the fate of many inventors: they invent the inventions, and others pick them up and run with them. All his life Franz tried to keep up with developments in the scientific world, but by his middle years this had become impossible. He once said that until the mid-1940s, a person could keep abreast of all new developments, after which it was too difficult, for knowledge had started to expand at such a fast rate. But he still had all the journals sent to him. When friends came to stay with me, I made

sure that among the copies of *Chemical Engineer's Monthly* and *Plastics and Industry*, the latest issue of *Rubber News* was put well out of sight, for fear of misunderstandings. After he died, we found volumes and volumes of his diaries, all impossible to read because his handwriting had always been illegible. They sit on their shelves, unread, reproachfully I sometimes feel, when I sleep in the room in which they were written.

He had the great gift of combining different cultures in his life, spending his days designing industrial inventions, his evenings reading or listening to music and following the scores, and his weekends building the garden, which even now has a breathtaking rightness about it. Later it was said that he had been a great gardener. My mother thought he hadn't been aware just how good he was. He planted all the orchards in the early years – damson, Victoria plum, apple (the pale green, incredibly sweet Keswick Codlin, which seems to have completely disappeared from the world, as well as the more usual varieties like Worcester Pearmain or Cox's Orange Pippin) – and tended everything in the garden with a real understanding of how it would develop in the future. He would have been aghast at the current television programmes that demonstrate how to build a garden in a day. Instead he would have agreed with Patrick White, who said that nothing beautiful was ever made in a hurry.

My father loved mountaineering and skiing (in the early days of the sport, before ski resorts), but he put these activities behind him in middle age. He took up riding, and he loved walking through the countryside, until that, too, became impossible for him. But most of his many problems really stemmed from an inability to relate to others. My mother put this down to the

fact that he had been brought up, together with his deaf and much-loved brother, by governesses. He only went to school at twelve or thirteen, when his father Karl died in the Spanish 'Flu pandemic of 1918, leaving them penniless in their splendid house. Not having had the usual childhood relationships, he had trouble grasping the idea that other people were not the same as him. This made him an appalling teacher, whether it was trying to help me with my maths homework, which inevitably produced tears (on my part, that is, although I dare say he felt like crying at his daughter's incompetence), or later, when he was already ill, and I had to drive him somewhere. On that particular occasion, I remember with horror, he attempted to instruct me to switch on the right-hand indicator and overtake the car in front. Unfortunately what he actually said was: Turn on the windscreen wipers and take a left, which was pretty confusing, not to say dangerous, at 50 or 60 miles per hour.

By then he had lost the supreme vigour and energy of his early years. Although I have to say he remained good-looking until the last, aged 81. My mother would still cuddle him and say: Look what a handsome man I married. That is why she put up with him all those years: because he was so handsome. After he died, she described their relationship succinctly. Your father and I, she said, had a wonderful marriage. There was just a sticky patch of some 35 years in the middle. In the very last week of his life, when I had been caring for him while my mother and sister were away skiing, I had to take him to hospital. He was longing for his Pauli, who was to return all tanned from the sun, and said to the nurse: She will come tomorrow, you know. You will recognise her because she is very small, with a brown face.

Tess Jaray, *Field, Red*, 2011

These paintings are landscapes. Or about landscape. Their subject has shifted from architecture to the natural world. This seems to me to have been inevitable. For years and years – decades – the impact of my first view of Italy remained dominant. We are surely creatures of circumstance, and the circumstances in which I first visited Italy were the postwar years, before all the rebuilding and the loss of much of the agricultural north. I left impoverished England for a land of impossible beauty, and at a time of life when would-be painters are at their most impressionable. I was not mature enough fully to grasp the miraculous nature of that landscape, and it was the architecture, almost more than the art, that had such a powerful effect on me. I did not realise then that architecture cannot be separated from landscape. So those years and those decades went past, and no further visits to Italy ever dulled that first experience. They only enriched and substantiated it.

This is still the case, except that my earliest years, the years of childhood, are now asserting themselves: the English landscape in which I grew up – and still travel to see – is forcing itself on the paintings.

There is not really any narrative in them – if there is, it remains only speculative. But there is history, of which the paintings may be a trace. And perhaps there is an invitation to enter, to look over or beyond what is painted, even though that is an act of the imagination. This was not asked for, or looked for; it simply appeared in the drawings: ploughed fields, furrowed,

with the young corn-seedlings springing up, neatly lined in rows, rows of soldiers, tiny, green, delicate, their pale green mixing in the light with the red earth colour to give off a soft yellow glow. And the paintings are attempting to call on all that (the paintings, rather than any will on my part), to remember through the combination of deep purple and pale yellow the wet spring weeks when that local earth turns dark, dark damson-oxide, and the corn or the beet or the flax marry into it with the delicacy of their varying greens. And then the earth dries, it turns red, sometimes almost scarlet, like the sandstone from which the local church is built; and then it really dries out, to a pale dusty pink, and in some places is seen only on the paths between the crops, or at the edges of the fields.

How could this force of childhood sensations not express itself somehow, given a chance? But how far is that possible outside of figurative representation? There is very little in evidence. Most art movements over the last hundred years or so, although not all, have been occupied in distancing themselves from the beauties of the landscape, if not of nature. Probably rightly: after all, no art could compete. And merely taking some Romantic colour associations and playing games with them does not make a painting. For a painting – or indeed any art – to touch us at the level at which it means something, to touch us profoundly, it should probably refer to or evoke something from our formative years: our first impressions, our perception of the new, so hard to replicate in later life, the myriad sensations we experience before we understand it will not always be like that.

Perhaps this is partly why Renaissance painting, and previous or subsequent art that refers to the Bible in some way,

feels familiar. Very few of my peers left school without some knowledge of Biblical stories. Even if these ideas are discarded in later life, the familiarity and underlying meaning of the subject-matter will unconsciously open up much art of this kind. It might also be worth considering that until fairly recently we had been so accustomed to the subject of worship in painting that it may hardly have been noticed that the depiction of the worship of God has metamorphosed into worship as a thing itself. A metaphysical frame of mind may be embodied, in a painting, in a sense of place, even if that place is unspecific. Better so: every viewer may insert their own.

The landscape does not feature in many people's formative years. For most it is felt as something other, on the periphery of experience: an idea, or ideal perhaps, that barely impinges on their daily lives. So really it should be no surprise that the work of urban artists, or of those who depict figures in turmoil, such as Picasso, Pollock, Bacon, Giacometti or Joseph Beuys, has had a more direct influence on our view of the art of our time. They are not so distant. Their subjects are closer to our private understanding of the world around us than the changing seasonal light on a ploughed field, the brown water of an overflowing river after a flood, or the pink dust of dried earth. Perhaps one should remember the old saying that a painting is its own country.

Tess Jaray, Drawing for *Wing*, 2009

Sometimes a little light shines on one's lack of understanding. I just read, in a book by Christa Wolf, the words: As everyone knows, you can't see what you don't know. It's true, of course, everyone does know that. Many people know, for instance, the story about the schooner moored in a bay off the coast of what would become New Zealand. The inhabitants of the island took no notice: never having seen such a thing before, it clearly didn't exist. (The fact that, so the story goes, they ate all the sailors when they came ashore doesn't detract from my point.) But until now I have not applied this idea to painting, abstract painting in particular, and perhaps my own even more particularly. When a person looks at a painting of a tree or a dog, a battle or a seascape, there is always that recognisable element to draw you in. No matter how changed or charged – distorted like Picasso or simplified like Matisse – there is always a hook to make you feel that you are on familiar ground. Even with non-figurative sculpture, its very objectness is itself a kind of figuration: it's so clearly there, in the world, and so doesn't really puzzle people that much. And I suspect that even with certain radical artists, the squareness of Malevich's square or the all-over drips of a Pollock – even Mondrian's geometry – are enough to provoke a sense of familiarity. But there are some abstract artists – one might name Kandinsky, Clyfford Still or Agnes Martin, possibly also Rothko – who provide no easy point of entry, and their work is consequently found much more difficult (although Rothko's images are now so ubiquitous they have become accepted). The

question 'What is it?' is still applied, even after modernism and its aftermath could be assumed to have altered perception. In spite of the radicalisation of art over the last 100 years, we haven't yet learned how to see anything unless we know it already.

My garden in spring

17. MY GARDEN

My garden is surrounded by houses, but I can't see any of them. The rambling roses have rambled beyond reason, so the world is shut out. Perhaps this is an attempt to re-create my childhood: in the countryside in which I grew up, it seemed that nothing had been touched for a thousand years. All the while, of course, I was longing for the city. What a waste. But now I am re-creating that countryside here in the middle of London, and for the first time I understand the need for animated nature. Winds and swaying trees are not enough. There must be creatures nesting in those trees and rustling in the undergrowth. My blackbirds have recently deserted me – I say they are mine because I am possessive about them and feel forlorn because they have gone. They aren't frightened of the squirrels, so is it the recent invasion of the pigeons? I wouldn't blame the blackbirds; pigeons are charmless. They have no intellect, unless they are homing pigeons, whereas blackbirds are sharp. At least they put up a great show of sussing out the terrain, but maybe it's just bluff. And if I had a choice, as they do, having both legs and wings, I would fly rather than hop. But maybe they were just eaten by the jays.

The hedges must be animated, they must move and shift and be a stage for life. Even if the movement is only sensed behind the lattice of leaves. Like a painting, it need not – indeed it should not – reveal itself instantly. Even though everything is laid out and can be perceived at once, that is an illusion. There is reward, if not virtue, in waiting.

Top: Gixi with his granddaughter Tess
Below: Letter to Leopold known as Gixi

When my sister and I were children, my mother often entertained us by telling stories from her own childhood, so that her lost family and old Vienna became part of the fabric and furnishings of the cottage that was now her home. Her love for this home was at least as great as that which she had for her family. She loved its tiny rooms, its oak beams and sloping floors, never for a second mourning the grand spaces of her parents' Viennese apartment, the enormous sofa and chairs covered with cinnamon-coloured (or was it rust?) suede, the porcelain-tiled stove, the curtains that were changed twice a year, or the blue enamel door plate – no. 8 Hahngasse – placed above a bronze confection of garlands of roses and fruit. I, on the other hand, pine for those rooms I never had. Now, when space seems to be the currency of our lives, I long for the high ceilings with their curved and decorated stucco, the vast windows set deep in the stone façade, and the patterned and polished parquet floors.

There were many stories about her beloved father Leopold, for some reason always known as Gixi. He had come to Vienna from Moravia as a young bridge-builder in the late nineteenth century, and had risen in the K und K – König und Kaiser – to become a Herr Ministerialrat, a high-ranking civil servant. My mother always took great pride in this. Recently I discovered letters kept by B, the guarantor of my parents' entry to England, among which were some from Leopold. B wrote about their correspondence in his own memoirs of that period: *Letters from Franz's father-in-law, aged 75: Ex State Councillor for the East*

for twenty years, and now ex-everything. (Ex-everything, because after the Anschluss all honours and titles were stripped from him; non-Aryans were not permitted to hold any position, but the time had not quite come when their possessions would be taken away, and, finally, their lives.) B continues: *This letter was written after we had 'rescued' Franz from Austria. Pauli and her infant were for the moment hostages, still living in Vienna with her parents. B. June 1938.* Leopold had written, just before they had been forced out of their apartment: *We shall never forget the few really agreeable days we could spend in your agreeable company, and the few hours you honoured us by your visit in our flat. But most of all let me thank you for your unrivalled friendship you are proving to the father of your God-child, our only sunshine. We can only repeat, Thanks, Thanks. We shall ever most gratefully think of our English friends whom we beg not to forget family Arndt.* And at the end of his reply B had written: *Our God-child shall know of the inheritance of culture and kindliness which is hers.* As indeed she does.

Leopold had many passions. His adored wife Helene, fifteen years his junior, who played the piano all the time, wonderfully (he called her La Belle Hélène, after the operetta of that name by Offenbach, which was all the rage then). His beloved Vienna, of which he knew every corner: each part of the Kärntner Ring, the Schubertring, the Neue Burg, the Staatstheatre, which had been designed by an uncle of his, the Karlskirche, and the Stephansdom, with its great south tower (pure Gothic), Romanesque West front, Renaissance cupola and nineteenth-century glazed-tile roof. And the art that he collected: where did it all end up, I wonder? The Schiele drawings, the Franz Wazik

sculptures and the hundreds of paintings by his artist-friends. His collection was of its time, a living thing, not something acquired merely to define his status.

It has been said that the Viennese bourgeoisie acquired its particular character during the third quarter of the nineteenth century, the period of industrial expansion. Leopold was born in these years, so between them he and his daughter Pauli lived through probably the greatest changes and turmoil that Europe had known since the Middle Ages. I find astonishing the idea that a person could be familiar in one lifetime, as Pauli was, with the images of both Emperor Franz Joseph and Margaret Thatcher. Pauli and her father crossed the divide between the complete collapse of the House of Habsburg and the development in the 1920s of modern Austria and social democracy, of which she was so proud to have been a part. She spoke often about the leader of the Social Democratic Workers' Party, Victor Adler, of how inspiring he was, and how much had been achieved for the people of Vienna at that time. Adult learning centres were initiated, libraries were created, sports centres built, as well as workers' housing that was the pride and joy of every social democrat, in spite of the stories that abounded, my mother told me, of the residents keeping coal in their new baths. One of the effects of her experience of this remarkable period of modernisation and social change, arguably the most radical in twentieth-century Europe, was that nothing ever seemed truly modern to her again. She was difficult to impress on that score. Oh that, she would say scornfully, we did *that* thirty years ago in Vienna.

It is not for me to write about the Dual Monarchy, the decline of the Habsburg Empire or the Austro-Hungarian

Kingdom. That period was already too far in the past for my parents to talk about it much, or perhaps the nightmares they had lived through had obliterated their memories. But I would love to be able to re-create for myself the Vienna that Leopold/Gixi knew and loved so well at the turn of the century, when he was in his prime. Everyone knows its mythology: Strauss waltzes, coffee-house culture, ritual and glitter and ceremony, music, horses and carriages, the Demels and the Sachers, and the Vienna Woods. Some know, too, that this façade of opulence and ostentation disguised the realities: many citizens were out of work and so destitute that they had to share rooms and sleep on a rota, spending their days in the coffee-houses, where they were permitted to stay for hours, reading the newspapers and journals for the price of just one coffee. A Viennese coffee, for sure (and always with the accompanying glass of famous Viennese well-water), and that could be black, white, dark brown, large, small, with *schlag* (whipped cream), with chicory or without, even an *Einspänner* (with equal amounts of coffee and whipped cream, piled high and sprinkled with chocolate) – but still just one coffee.

The reality of Vienna at this time was also a self-important and desperately restrictive bureaucracy, a decaying aristocracy, prostitution, rampant corruption and rising anti-semitism. But for Leopold-known-as-Gixi, I imagine, these contradictions were part of his life, a backdrop to the city-stage, this Mecca to which people were drawn from across the Empire. He himself had been drawn to it; the small Moravian town in which he grew up would not have seemed large enough for his talents. And perhaps when he arrived in the great city, its patina of age was at its richest, after

the rawness of the new nineteenth-century buildings, but before decay and decadence had really set in.

More than anything else, though, more than anything else in the world, Leopold adored his daughter. Perhaps he was also the love of her life, in spite of her 52-year marriage and many previous lovers. She told us stories about those men, too. About her immense passion for the famous actor Moissi – I think she saw his *Hamlet* 27 times – to whom she gave her virginity, and how it only ended when her desperate father went to see the Great Man and put a stop to it. And the last lover before her marriage, the psychoanalyst René Spitz, whose name appears occasionally in analytical writings of the time. His gift to Pauli of the finest, softest woven silk scarf, in deep reds and golden yellows, bought in China in the 1920s, still rests in my drawers at home. On the rare occasions I wear it – it weighs nothing at all – I feel close to the silkworms who gave their lives for it and were probably fried and eaten afterwards. The affair only ended when she met her husband-to-be, of whom René approved, apparently, and they all remained friends. There was to be a very similar pattern of events in my own life many years later.

Perhaps it was her lover's satisfaction with her marriage that made Pauli quote the Somerset Maugham story 'Appearance and Reality', in which the grand and elderly lover of a young French mannequin is appalled to find her in bed with a handsome young man. The older lover can only reconcile himself to the affair by giving her a dowry large enough for her to marry the young man. If he were my husband and you were my lover, she says in good French tradition, you would think it perfectly natural. Obviously. For then she would be deceiving the young man and

the older man's honour would be secure. Honour must have been hard to come by for women of my mother's generation: so many possible suitors died in the First World War; there was a dearth of men of marriageable age. My father was a little younger than her; born in 1906, he missed the war by a few years. And judging by the photographs of her at that time, she was exotic as well as lovely, her skin always smooth and brown from the hours spent in Viennese rooftop sun-baths, and her hair jet black and seal-sleek, pulled back to look like Josephine Baker, the star whom she adored and emulated. In fact, my mother only changed her hair-style twice in her long life: once to soften the bun in her middle years (at that time it was called a chignon), and again when she turned first grey and then the finest, purest white imaginable. At the very end of her life, when she could no longer do it herself, my sister and I loved to comb her hair and make a little plait tied with a ribbon, for the night.

From her father Pauli inherited a love of the English language; indeed, of the English people and almost everything about England itself. And that was many years before this country had offered her refuge. After she came to live in England, Pauli and Leopold often wrote to each other in English. On a postcard written at the time (although it is not dated, it must have been sent after the summer of 1938, when my mother and I arrived here, and before September 1939, when war was declared and all communication ceased between the two countries), he expressed himself in a way that seems remarkable even for that period. Referring to the illness of an old friend, he wrote: *Your card, Darling, gave me some Lebensmut and Lebensfreude* [courage and joy]. *It is a sad event to know his best friend in bad health, and to*

know him so far away from his devoted friends, who were happy to help him. Your statement that 'it's the life that matters, and not the end' is an aphorism, worth to be retained in memory. As soon as possible we'll write. Allow me to repeat to be cautious; the season is a treacherous one. Many kisses to all of you, Father.

When they came to this country, my mother told me, she dreamt every night about the parents she had left behind. They nearly made it, she said; all the papers for entry had finally been completed and gathered together ready to send, and on that very day, 3 September 1939, after the most beautiful Indian summer that anyone could recall, war was declared, and it was too late. As soon as she heard of their deaths, later on, the dreams ceased. And which of us have not asked ourselves, at some time, if they are really true, those words that she wrote to Leopold – it is the life that matters and not the end?

There are other letters, from earlier and happier times, to English friends, describing, for instance, the new flat into which she and her new husband had moved in Pötzleinsdorf, just outside Vienna: *It is lovely! Small (just two moderate-sized rooms, kitchen and bathroom), so that I (Pauli) can easily manage the housework and I (Franz) can easily pay the rent. Clean, bright, full of sunshine. And the best of it: it is simply wonderfully situated. A little outside Vienna, not too far, with a lovely garden and a marvellous view all over Vienna – right from the windows. In the evenings we see the lights of the city sparkling in the distance, hear the song of the crickets in the fields, smell the flowers in the garden and are infinitely happy. You must, oh you simply must, come and visit us!*

A circle

Someone, possibly Flaubert, once said that anything can become interesting if you look at it long enough. This is probably true, and a real danger for an artist. For an artist spends so long staring at the work in progress, that it's bound to become interesting. How do you separate what merely appears to be interesting – because by gazing at it for some length of time it may become a receptacle for all kinds of ideas and emotions – from something that really is interesting, and perhaps won't reveal its secrets all in one go. Or even for some time. Because a successful work isn't something that is produced by careful effort and clever thinking. Effort and thought may or may not be part of the process, and may or may not play their part, but it is only when an answer to an unarticulated question appears, as if on its own accord, as if from nowhere, that something of value may be achieved. Heidegger said that meaning is not received from things, but given to them. This is a mystery and a conundrum, because if I give something meaning, how can I know that others will perceive it? And if they don't, perhaps I am just fiddling while Rome burns?

Hair-roller with bottle-top, used by bee-keepers
in Yemen to house the queen bee

It is said that the best honey in the world comes from Yemen, particularly the Wadi Rakhya and the Wadi Jirdan. Bee-keeping was widespread there even in pre-Islamic times. In 1441 the Egyptian historian Al-Maqrizi wrote: 'The whole of Yemen is a land of honey.' The social organisation of the bees was indicated by the Prophet as a model for the community of believers, and bees and honey carry a blessing. Since the time of the Prophet, honey has been used as a remedy for everything from wounds to toothache. Considered to be important for fertility and physical strength, it is given to young bridegrooms and circumcised boys. In the Koran it says: 'In Paradise rivers of pure honey run.' In Yemen's Wadi Dawan, the bee-keeper identifies the queen among the wild bees, captures her and puts her in a small box built especially for the purpose, then inserts the box into a woven cane mat rolled into the shape of a hive and closed at one end, so that the bees can follow her in. Since time immemorial the small box has been carved, with great artistry and intricacy, out of wood. I have never seen one of these marvellous edifices, not even at the British Museum or the Victoria and Albert. And perhaps I never will, because the modern world has reached even those distant Wadis. Instead of wasting time, inventiveness and craftsmanship carving a minuscule work of art for the queen bee to rest in, they have discovered that a plastic, colourful hair-roller does the job just as well. So now, there she sits, ruling over her swarm, in a shiny new pink or blue hair-roller, and probably – at least so I hope – considers herself to be a very advanced bee indeed.

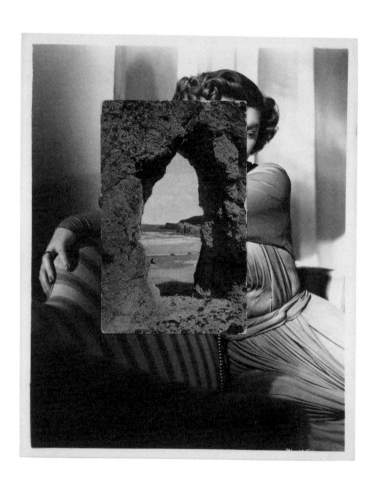

John Stezaker, *Untitled*, 2012. Collage

The Shangri-La seen through the opening of the rocks, the 'open sesame' of the rocks themselves, the echo of the call of the Sirens beyond the calm sea. There is an unexpected calmness here. This subject-matter might so easily have been heated, febrile, with the impossible perfection of the hidden female – the Siren – inviting impossible responses.

A great deal has been written of 'the frozen moment' in art. It is found in many paintings and is the aspiration of many artists. But it is not so often – or so easily – grasped that on occasion that moment is extended into perpetuity, and the frozen becomes something more like a state or condition. This text is a response to a particular image, *Untitled* by John Stezaker, not a discussion of his work in general, much of which varies greatly in content from this one, although rock openings have been a strong theme. In the case of this image he has caught something rather different. It might be called 'the ecstasy of the unattainable'. Desire and longing for something, a particular something, if unattainable, may bring pain and sadness. But desire for something that is in itself totally out of reach is another matter. It may have such power and sweetness at its centre that it comes close to being an object, one that is both immobile and forever in motion. It can become something about which it is impossible to be exact, and something that can calm and magnify you. It can remove all striving and despair, allowing you to touch on it as a reminder of the heights of existence, and it can give you strength. I wonder if this is part of the essence of Romanticism?

there are many truths + realities as there are people.

John Stezaker's work has been called, among other things, 'absurdist'. It is not. It is the opposite – if that can be defined without turning it into hyper-realism, which it is also certainly not. Art may not lie, but neither does it necessarily tell the truth, and *Untitled* stands somewhere between these poles. Much of what has been said of his work is indeed true: its secrecy, its play with depth and surface, glamour and social superficiality, fantasy and reality.

But you don't have to work at seeing this image. It comes at you. It doesn't even open up to you; it is already open without the asking. In his work there is a strange alignment of the primitive and the sophisticated. A turning inside out. A bringing out of the hidden, and a hiding of the object. This is surely beyond desire. Behind it. Put in the past tense so that you are left with only the moment.

I'm not certain that critics of Stezaker's work have spoken of the difference between the very personal and private responses that may be evoked in male and female viewers looking at one of this series. In this particular image, *Untitled*, I suspect that the male response would partly be intellectual, probably in order to – at least momentarily – avoid the directness of its sexual impact. Would any man wish to confess to such blatant perception of a woman more or less holding aloft her vagina for his inspection? Or even to perceiving the work as a clichéd image of the vagina as a wound? Or that it offers him dreams that might be better kept private (at least he hopes they are). There are, after all, useful disguises to help the male viewer fool himself: the form-ality and filmic elegance of the woman's pose, the exquisite upholstery echoing the dress of the subject, the perfectly coif-

fured hair, the abstracted gaze. Above all, perhaps appreciated with a sense of relief, the fact that the face is hidden.

Who would dare to interpret this, even in his innermost being? Would the eroticism be too provoking, too disturbing for all this perfection? Would this male viewer not long to ruffle the hair, disrobe the robes, stain the sofa? Because the reward is there in front of him, not just beckoning, almost a promise. Surely he just has to enter and it will be his? But: perhaps this image is in fact quite other in its meaning. Perhaps it is not an offering to the 'male gaze', but to the female subject. This artist is not a hater of the female sex, but her lover and admirer. He seems to rejoice in the woman, without feeling that she is unavailable or distant or from another time. He is saying: this is of the now, but perhaps rather in disguise. After all, he implies, I don't want to reveal too much of myself either. And there is something too of 'after the event', a thankfulness for having known this, a memento of the other side, a record of Paradise, not just the conventional longing for the unattainable.

This is, of course, speculative, which is what much art is, too: speculative about a range of mysteries, both in art and in reality. And the response that I have described is not what I myself experience in front of this image. It obliges me – forces me – to confront something rather different: my own memories and desires, those private and secret thoughts of the past, and perhaps also of the present, which can never belong to anyone else, however much others may feel the same. I must confess that at the same time this image makes me uncomfortable, ill at ease. It asks me to face these – almost – hidden memories, of growing from a child to a woman, of the uncertainties of those early years,

of looking to the world for help and possible direction. What it really does, and this is hard to admit, is make me feel that I have been rumbled. How does anyone else know this about me? Can it be read in my demeanour? Is it really true that everything that one has ever thought or experienced is still present? That all you have to do is prick with a pin the cling-film covering that holds it back? I won't spell it out, it would be too shameful. And I comfort myself that the artist doesn't really know either. He must just have come across it by chance.

Tess Jaray, Drawing for *Five Curtains*, 2007

The notion of 'curtains' as a metaphor covers such a vast range of imagery that it reminds me – frivolously – of when I was told that in Mandarin Chinese the sound *ji*, pronounced in the fourth, emphatic tone, can mean many different things: to remember, to put down, already, a mark or trace, border, season. What an economic language, I thought, where one word does for so many meanings. Although it was then explained to me that it isn't a bit like that, because it is with the pronunciation that the difference is made clear.

But when I think of 'curtains' I am probably thinking in pictorial terms, or at least visual. For it seems to stand, in so many ways, for that thing that mysteriously divides us from 'the other'. The hidden meaning of things that is veiled from us. In Islam it is said that the sky is the curtain that separates us from heaven, and what we perceive as stars are actually the light from heaven shining through. In painting, the grid (which came under attack in the 1970s) was, perhaps unknowingly, an attempt to mitigate the severity of constructivism: this form of measurement could also be interpreted as a mesh or veil. Such materials have been depicted for so many centuries in sacred art and Christian symbolism that possibly it is quite difficult to use a grid in painting without unconsciously referring to them. The veil, the net, the curtain, the shroud, the veil as flesh, the hymen, the fabric that simultaneously reveals and conceals: these are so much part of our visual heritage that we are no longer always aware of them.

In spite of all this, when I think of the word 'curtains', the image that appears in my mind is not so rarefied or ethereal. It is the immense façade of the cinema curtains before a film starts, when the light changes across the fabric and they are transformed from shimmering electric blue to electric pink, or some other such vibrant and powerful – and wonderfully vulgar – colour. This is extraordinarily anticipatory.

Dear Ten,

your letter didn't come to
soon by any means. I was
much amused by your
likening the company of
the formidable Musil
to the sensation of having
a large rock in your room.
When I first read The Man
without Qualities, in the
winter of 1966/67, this was
pretty much how I felt
about it. There is this
anecdote about Musil
& Joseph Roth (a great fav=
ourite of mine): the two
had always studiously
avoided each other until
one day in a Vienna coffee-
house a mutual friend
brought them together! Well,
what did you think, the
friend said to Roth after=
wards. Well, said Roth, he
speaks like an Austrian
but he thinks like a ger=
man. [Perhaps that ex=
plains his intransigence].

Extract of a letter to Tess Jaray from Max Sebald

23. THERE ARE 23 ENTRIES
IN THIS DIARY

There are 23 entries in this diary. So far. At 23 it seemed to finish by itself, not only because the year was coming to an end. And 23 was the number of verses that Max Sebald gave to his 'Marienbad Elegy', and there were 23 in Goethe's 'Marienbad Elegy', which Max didn't really care for. And 23 in the Schiller poem 'The Cranes of Ibykus', which at first I had mistakenly thought was the original inspiration for Sebald. And 23 poems by Max in his book *For Years Now*, for which I did the images. 23 is a prime number, but what else is it that I don't know? It must have had some secret meaning for him. He refers to Rousseau having written 23 letters in a day, and to the father of a friend who was shot by the Nazis at the age of 23. And at the end of his life, in preparation for his next book, he was reading through 23 volumes of diaries written by that friend's grandfather. What did 23 mean to him? And now I see that 23 is not the end of this diary.

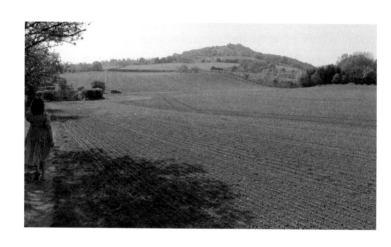

View towards Berrow Hill, Worcestershire

For the last half of her life, my mother woke to the mellow fecundity of the Teme Valley. She never lost sight of this amazing turn of events: that the urban child of deeply Central European parents had this great joy after so much sorrow. I grew up in that fertile place, but its ideal nature was sadly wasted on me, as I had the misfortune to be young then, and only rare and very lucky people appreciate their childhood at the time.

My mother always claimed that it was the most beautiful place in the world. More beautiful than the Salzkammergut, than the Tyrol, the Carinthian Lakes where she spent her summers as a child, or the Wienerwald, the Vienna Woods, where she went with her friends every weekend in the years before she met my father. And when my father and mother returned to Austria, albeit briefly, when they were both in their mid-seventies, this was confirmed for her. My father had suggested that they did as their old cat had done. Before she died the cat went to all the places that she had loved. It is in this spirit that I want to go to Austria and look at all the places I loved in my youth, Franz said. My mother was annoyed. What nonsense, she said, nowadays nearly everybody lives to be 90. We won't die for years yet.

So they went back. But it wasn't the same as before. The city was changed, and it didn't seem to mean much to her any more. Of course, she said, she had expected changes. She knew how much the little English cathedral town near where they now lived had changed during the last 40 years. But really, she thought, there hardly seems to be one stone left the same

in Vienna. Even the Stephansdom, the very symbol of Vienna, looked different. Its roof had burnt down during the Second World War, and the colours of the new roof were different, she felt sure. Kärntnerstrasse and the Graben, the elegant streets in the centre, somehow looked less elegant than she remembered. The shops were more garish. Traffic had been banned from those streets, which were now covered with tables and chairs, like one vast café. They were full of tourists. Somehow it jarred. Why, Pauli said, it's just like in Venice. Why do I love it in Venice and not here? The next morning it rained and the chairs of the outdoor cafés were stacked against the tables, empty and cheerless. That's it, my mother thought, they don't have the right climate for it. On the Ringstrasse there were still the beautiful old buildings: the Burgtheater, the Rathaus, the museums, the Austrian Parliament. The same old trams were running, although looking new. And the parks were almost the same. A tiny spark of emotion and memory – the first one – stirred for my mother as they walked through the Rathauspark and the Volksgarten. How often she had been there, 45, 50, 60, even 70 years ago! But the spark did not kindle. It has nothing to do with me now, she thought. It's a nice enough city to see on holiday, but it's not my home.

On the second morning, while my father went about some errands of his own, my mother walked slowly into the district in which she had been born, gone to school and grown up. She looked around the unfamiliar streets and caught sight of a street name. I know this one, she thought in astonishment. She remembered the name, but not the street. As she walked about, all the street names were well known to her, but

she did not recognise a thing. The following morning they left Vienna. The 40 years in England had taken hold.

But there had not been a *complete* transformation, of course. Rather, the layers and layers of their lives had distanced those early days, so that they were almost buried, I think, until the very end of their lives. Once, at breakfast, I asked my father, what was it like when you were interned on the Isle of Man? Terrible food, good concerts, he said. Pass the strawberry jam please. Rubbish, my mother said, he had a wonderful time there. My mother felt that she was the one who had had it hard. He had himself made secretary to the Commander, or whatever he was called, while she had to survive on a pound a week, all alone with a baby, sheltering from the bombs under the enormous desk that they had brought with them from Vienna. We lived in Orpington then, and the town was hit by German pilots on their way home with the bombs that had not been dropped on London. My father was then released to join the fire-fighting on the London roofs. He loved that too, my mother said, but it's all so long ago now. We've forgotten.

She had spoken, sometimes, of the sounds of the early Vienna years. The horses' hooves on the cobbles in her childhood, the trams later on. The delivery boys whistling the tunes from the latest operetta. Now she was waking to silence, broken only by the sound of wild creatures, birds or the sheep chewing grass. And to the seasons, which for years now had told her something quite other than it was time for skiing or for sun-bathing. Not only did she love the seasons, she loved weather, the unpredictable nature of seasons within seasons: winter in summer, grey skies in June, hot days in March. Not that she didn't complain about

it – she loved to complain about the weather – but it was always of interest to her. I cannot quite know what she felt when she rose early, as she did to get us all off to school and work, and looked out of the window at the thick white mist rising to the top of the valley. But when I see it swirling, shimmering with whiteness, insubstantial yet somehow tangible, all I can do is gaze and gaze, and understand: that must be why my father needed to climb mountains in his youth. To feel oneself absorbed into nothingness, as must happen when you climb up to the clouds.

In those early days the hills were wooded and the meadows encircled with copses. Those copses have now been 'rationalised', which means cleared for useful production, and the woods, if not cut down for timber, have been decimated under the careful eye of the Countryside Commission, which insists that the trees must be 'maintained'. Perhaps they are right. Views are now opened out and new growth is springing up already. But I mourn the magical darkness of those impenetrable places and the rustle of the foxes and other creatures who made their homes in them. I remember the slight, very slight, tremor of fear as one looked into the dark centre. And I notice also that although these places are now in principle more accessible to the public, in practice the tractors leave such deep ruts that walking there is almost impossible. The tracks used to be covered with layers and layers of leaves that had fallen over the years, creating the softest, springiest, most fragrant path imaginable.

But the earth there remains red. If one travels by train from the south of England to the north, it is remarkable how you see the colour of the earth change. Different browns, greys, yellows. But there, in my mother's county, the earth is still red. It is a

red that changes from field to field, from day to day, and from morning to night. When that earth is ploughed, the furrows are Venetian red, deepening at the edges to a glowing Indian red, sometimes so dark they are more Mars Violet or Burnt Sienna. At other times the earth lightens to cadmium or vermilion red; John Betjeman, in his book on parish churches, describes the sandstone out of which the local church is built as scarlet. And when you get home after walking on the heavy, dried clay earth, it has become pink. I am reminded of being told that the Maasai have 37 different words for red, on account of their profound devotion to their cattle. I wish I knew what they were.

It is a truism that the seasons of our childhood seem very different from how they actually were. When I look back to those weather days that my mother knew, I cannot disentangle them from my own. But I think that our early experiences have much in common with later ones that are also first experiences. And, perhaps, that we go on seeking that first experience to the end of our days. I do not mean in memory or recollection. I mean the startling revelation of seeing something for the first time. Whenever I see a Scarlet Pimpernel, I remember exactly where I saw the first one, and how I crouched down to examine its perfection, its delicacy, its geometric arrangement of five petals, its scarletness, with a purple heart and yellow stamens, and above all its tiny size. But these first experiences also continue to happen forever. Quite recently, for instance, I went to a *hammam* in North Africa and went through the ritual of being washed by a woman who drew water from a single tap into a plastic bowl, then scrubbed, while lying on a hard stone slab, surrounded by old Moorish tilework in the dripping warmth of an underground

room. This was truly a fabulous first experience. The next time will also be fabulous, I hope, but by then it will be familiar – perhaps no less a pleasure, but not the same.

What I am getting at here is that, although my mother was not a child, indeed not really young any more, when she saw, on a silver winter morning, cobwebs picked out in precise detail by minute particles of frost, for her, having come from Vienna, it would have been a first experience. As would the first of those rare, far too rare, May days when the sun shone, still fairly low in the sky, and lit up the first emerging buds of the grasses and wild flowers that abounded there. If I tried to count the times such days actually occurred during my childhood, I suspect I could do so on the fingers of my hands, or twice that number at most. I wish that I had asked her about her early memories of nature in Vienna. She spoke often of her wonder at the fact that it was permitted to walk on the grass in most English parks; in Austria, it seems, this was not allowed. In Austria, it seems, very little was allowed, and her descriptions of the labyrinthine convolutions of their bureaucracy was something I could never really grasp until recently, when I attempted, unsuccessfully, to obtain a parking permit for my friends when they come to see me, as, not owning a car, I don't have a permit myself.

Exit-permit stamp from Vienna, 1938

25. EXIT PERMIT FOR THE
BLUE CUPBOARD

I discovered, only quite recently – to my shame – a small stamp on the inside of the door of the blue cupboard. About 3.5 cm wide, this stamp is what remains of an exit permit, which authorised certain articles of furniture, and presumably art as well, to leave Austria. In the case of the blue cupboard, this would have been between March 1938, after the Anschluss, and August of that year, when I came to England with my mother, my father having left sooner as he was in greater danger of being arrested. The Anschluss itself took place on 11 and 12 March, and 11 March happened to be my father's birthday, so it was mentioned every year.

It is strange to realise that all this occurred so recently in history, that I was already born, although at three months old not much of a witness. And how was it that they were permitted to take with them something that was clearly, even then, of some particular rarity, being so very Austrian? There was no problem, it seems, with the Bösendorfer piano they brought but were obliged to sell soon after reaching England. But the real mystery lies with the stamp. Although it is faded and difficult to read (originally I thought the words were in Gothic script), one can just discern a double-headed eagle in the centre. But then I learned that the double-headed eagle was replaced with a single-headed eagle after the First World War, with the end of the Austro-Hungarian Dual Monarchy and the birth of the Republic in 1919. So why did the eagle on this stamp have two heads as late as 1938?

Here began a complicated but fascinating trail of detective work. I asked both the Freud Museum and the Wiener Library about the stamp, but they have no record of it and nothing remotely similar. I then asked clever friends to help. My daughter's boyfriend Pascal, who is Swiss and speaks several European languages, wrote down the words for me: *Zentralstelle für Denkmalschutz*, which he translated as Central Office for Protection/Preservation of Historical Buildings. And on the lower half: *Im Bundesinstitut für Unterricht* – Federal Institute for Education.

But what about the anachronistic double-headed eagle? Next I asked Martin Stiksel, a new friend and, helpfully, an Austrian. After studying the stamp carefully, he went away and discovered a number of other versions, dating from a period of nearly 50 years. This is what he found: the double head was replaced with a single head following the creation of the First Republic in 1919. In 1934 the double head was reinstated. The coat of arms was changed on 1 May 1934, and although there is no known document changing it, presumably the state ensign was adapted, too, remaining in use until 1938. Between 1938 and 1943 the coat of arms of the Federal State appeared. After 1943 it may have been replaced with a symbol of the German Reich, but there is remarkably little information about this on the internet, or in fact anywhere. Perhaps the postwar Austrian government wisely concealed it?

My friend Louise happened to be with me while I was trying to unravel all this, and was interested. She gave the stamp her close attention. That is not Gothic script, she said. I didn't believe her. She took a close-up photograph. I was convinced. She also

queried the fine lines on the coat of arms, which do not appear on any of the other stamps I had seen. And after much research, Louise unearthed what is reproduced here. It is possible that this particular stamp is very rare. Who else still has furniture that was exported at that exact time?

My own view is that the customs officer in charge was simply too lazy to go to the trouble of having the old stamp replaced. Perhaps his laziness was stronger even than the powerful bureaucracy that ruled that part of the world for so long – think of Kafka. One day the necessary detective work might be undertaken to solve the mystery once and for all. But there are so few people left who will remember the details.

The blue cupboard travelled from its original home in Salzburg to London in 1938, and then on to the depths of the Worcestershire countryside, where it remained for 71 years. When I recently moved into a new home and studio, I felt its call strongly and had it brought back to London. It receives the admiration of everyone who comes to this old converted pub, and I worship it every day, as it deserves. Not only does it symbolically contain the history of the survival of my family, but the blue cupboard will remain with them into the future. I cannot imagine that they will sell it, even after a hundred years, when, just possibly, I may no longer be here.

Interior view of the Grand Hôtel Villa de France, Tangiers, 1991

There was only one place I wanted to stay. The Grand Hôtel Villa de France. The name resonated with grandeur and romance. It stood at the top of a hill overlooking the Mediterranean. This was the hotel in which Matisse had stayed for some three months in the spring of 1912, where he had painted some of the most sublime works of his career, in spite of almost daily rain. Of course I wanted to stay in room 35, his room, which I later saw was remarkably small for the birthplace of such masterpieces as *The Casbah Gate* and *Landscape Viewed from a Window*. For some reason that wasn't possible, although I got a clue as to why when we had to try five rooms before we found one whose door locked or light worked. To ask for running water seemed excessively demanding. There was a telephone, but it only took incoming calls. I could have left and gone to one of those nice tourist hotels with mod cons and en suite everything, but that seemed self-indulgent. In any case, I wanted the view from my window that Matisse had enjoyed.

I got it. The same palm tree, grown much larger of course, and the same little English church – St Andrew's, I seem to remember – that he painted several times. I was very happy. I didn't mind that in this grandly named hotel, set among palm trees and bougainvillea, with exquisite though dilapidated tiled fountains still dripping a little water, and a swimming pool, overgrown with greenery, that had clearly not seen a swimmer since Matisse was there, absolutely nothing worked. Having finally secured a room and fallen fast asleep, I was woken at three

in the morning by the single light that worked and found myself staring into the face of a strange man. Excuse me, he said in French, I was looking for my wife. The next morning I realised that there was an unlocked door leading to the neighbouring room, and that it was perfectly clear that his wife was the very last person he was looking for. As there were no curtains, of course, I had been sleeping with a mask, so perhaps he thought I was Dick Turpin and took fright.

I was the only person at breakfast in the morning, which was served (served? Rather, brought in) in the grand dining room by an agitated young man. Marvellous silk curtains, gossamer thin with time and neglect, framed the crumbling windows, and brocade-covered chairs, a few gold threads still clinging to them, were set around the tables. The tablecloths were made of that fine white linen that you don't find anywhere else, but they were threadbare. Imposing chandeliers hung from the ceiling. Sunlight poured through the patterned, thick-glass windows in rays of diffused colour, and the floors were tiled with old patterned tiles that were warm to look at and cool to the touch.

There was certainly no sign that Matisse had ever stayed in the Grand Hôtel Villa de France, and I found it very hard to imagine him setting out in the morning, formally dressed, carrying his painting materials and a little stool to sit on, the one that we know about because he drew it several times. Altogether the place was fairly empty, and there was a somewhat strange atmosphere. I was regarded with curiosity by the people in charge, and there seemed to be very few other visitors. I stayed for a week and got to know the wonderful, seedy, decaying city, with its rich history – remnants of the 1930s, '40s and '50s,

when it was an international and financial refuge for English and American bohemians, and the building in which Paul Bowles still lived, although well into his eighties by then, and his playmate Jane long gone.

On my last day I packed and waited for a taxi to take me to the airport. I sat in the lobby with a handful of other people reading newspapers or staring into space. I noticed a girl sitting alone, wearing a djellaba and with her head veiled. In spite of the coverings, I could see that she was both very young and very pretty. Then suddenly, as if from nowhere, the same young man who had served me at breakfast sidled up to her, glanced around to make sure that no one was looking, and bent down to whisper something to her. She then got up and disappeared. In my naïvety I simply hadn't seen what was now clear as daylight: I had been staying in a brothel. No wonder the man who had entered my room in the middle of the night had looked so peeved. What would Matisse have thought?

The following year I returned to discover that the hotel was shut and locked. By now I imagine that it has been pulled down, its Art Deco fittings and crystal chandeliers sitting for sale in the souk, replaced by a proper modern building with all the personality of a bent hairpin.

Richard Plank, *SOE 1*, 2013

27. THE WORK OF RICHARD PLANK: SYSTEMS ART RECALLED

The image of the artist living in isolation and removed from the world is a familiar one, and has surely been so since Romanticism. Mostly it is in some way connected to the idea of retreating into Nature, being surrounded by a landscape that gives inspiration to the work.

Richard Plank is different. Although he has lived for many years in isolation at the furthest south-western point of England, his work has always seemed to me essentially urban. He was, after all, born and bred in London. But the storms, the sea, the wilderness and the loneliness have seeped in, mitigating the hardness of expression that might have characterised his work had he remained in the city.

Out of this conflict of nature and the city – which perhaps he has never seen as a conflict – has emerged his own particular, developed and developing, interpretation of what started out as Systems art, a movement that was almost entirely urban. It came out of De Stijl, Constructivism and Mondrian, who himself was said to have complained if he so much as caught sight of a tree.

This is not intended to be an exhaustive overview of the movement at that time. Anyone who is interested could refer to Lawrence Alloway's catalogue introduction to the very influential exhibition on the subject at the Guggenheim Museum in New York in 1966. This is how he described it at the time:

A system is an organized whole, the parts of which demonstrate

some regularities. A system is not antithetical to the values suggested by such art world word-clusters as humanist, organic, and process. On the contrary, while the artist is engaged with it, a system is a process; trial and error, instead of being incorporated into the painting, occur off the canvas. The predictive power of the artist, minimized by the prestige of gestural painting, is strongly operative, from ideas and early sketches, to the ordering of exactly scaled and shaped stretchers and help by assistants.

There are few now who remember much about the British Systems art movement of the 1970s. Looking back, it seems to have been a brief moment, around 1970, bridging the old – American Abstract Expressionism in particular – and the new: what might generally be called Conceptual art, together with the subsequent development of pluralism and eclecticism (which until they became terms of approbation were anathema), and then what is known as global art.

It is impossible for a young art student not to be influenced by their context in the early years. That, after all, is why they are attracted to art schools in the first place: to explore this thing – art – to which they are drawn but don't yet know anything about. Before this explosion, the idea still held that art is utopian and progressive, and that is what Plank was exposed to as a student at the Slade in the early 1970s.

It was a turbulent period in the British art world when everything that had come before was challenged. It's very hard now to recall the dominance of Abstract Expressionism, which had held the stage for so many years, and was beginning to lose its impact under the influence of Conceptualism. So what is

startling, looking back, is the fact, which could not possibly have been seen at the time, that British Systems art sits exactly at the cusp of art changing, and changing *forever.*

Coming into being at precisely that moment, this movement was never really given the chance to expand. Not only did the explosion of so-called pluralism and the excitement of radical new forms of art take things in a different direction, but it was heavily criticised – for using what was considered to be the safety and security of the grid, for example, and the right angle, which was often present in some form and to many appeared to lack dynamism. With all the new developments, these elements suddenly seemed redundant. Stability within art was not considered to be of value. But for painters of this movement, the grid was, perhaps unknowingly, an attempt to mitigate the severity of Constructivism. It could have been interpreted in other ways as well: as a useful simplification of proportion, as a mesh that veils the unwanted, as a hidden reference to the Renaissance. But that was not the way it was seen.

Very few artists have survived the chaos of this period and remained faithful to its precepts. Of course it takes courage and imagination to break free of anything and move on, but equally it takes courage to cleave to original certainties and attempt to delve into their meaning. Very few have chosen to develop the principles of Systems art, to take what they considered of value, discard the rest and look deeper into the possibilities suggested, perhaps only hinted at, opening up these principles to a more personal – and possibly, simultaneously, a more universal – set of values. Richard Plank has done this. He seems to me to have set out to explore the limits of stability, to see how far his works may

be contained within his chosen parameters without breaking. But they have taken him on a journey that he could not possibly have foreseen in those early days.

At that time this movement was predicated on a simple and clear precept: to create a system for making art, according to a few fundamental rules. For example, to start a work with a simple shape or form, usually geometrical, a square perhaps or a series of prime numbers, and set up rules or procedures that will determine the outcome, how the finished work will look, without recourse to aesthetic decisions or preference. The decision-making was therefore determined at the start, and all work flowed from this.

In many ways Richard Plank has remained faithful to this precept, but his work has changed over the years into something very different. The constraints that he imposes on himself are limiting. And yet from them emerge real surprises. In the recent work *NCS* – his titles give nothing away, indeed they might be an attempt to camouflage any escaping expression – the expression emerges unasked for, possibly even unwanted. There is now a lightness of touch, and even on occasion something humorous. Humour frequently appears in art through distortions and extremes of scale, but in this particular work it seems instead related to the lines taking on a life of their own, dancing out of control, like children evading their parents.

There is not much point in describing the individual works, as without images not much would be gained. But what is so remarkable to me is the fact that within the limitations he has set himself, Plank has made works that are not only expressive, but demonstrate a wide-reaching range of expressions.

In the early works it is easy to see how he was exploring his chosen language. But by 2008 something very different happened: he discovered a completely personal way of using his basic elements, and an extraordinary breadth of emotion is seen within works of a relatively short period. And as the work progressed, an unexpected feeling of warmth, even poetry, began to emerge.

Between 2008 and 2012 we see the harmonies and serenities of *RYBG*, the surprise and delight of *Eight Elements Describing a Square*, and the unmitigated humour of *Untitled 25.5.12*. In 2013, the fantasy and joy of *NCS 2013* and the beauty and tranquillity of the series *SOE 1–8*. Later in 2013, again a very different element emerges: in *RYBG 2013* there is a strong sense of something caged, trapped, trying to escape. This last series, *RYBG*, seems to be not only explosive but to have something of desperation about it. My own particular favourite series is *SOE 1–8*. The extraordinary beauty, tranquillity and rightness in these works are impossible to account for, given such pared-down imagery. And why, considering the simplicity of the geometric shapes, do they evoke so many other things? Not just a satisfying sense of order, proportion and scale, but the stitching of fabrics, weaving, planting in spring, the ordering of things that constitutes the warp and weft of our lives.

This is difficult to understand, given the strictures of the limitations that Plank has set up. So what is it, you ask yourself, in these simple forms, that evokes such a response? But you may as well ask why passion and excitement are generated by the move of a pawn or a bishop in a game of chess. That is how it is. Life and experience and desire assert themselves within art, without

necessarily being invited to do so. Plank's work aspires – as does the work of so many artists – to the condition of timelessness. Impossible though this may be to achieve. But geometry itself holds that promise, for it is itself timeless, and this is one of the mysteries of transposition.

Plank's recent three-dimensional works are very different in feeling. In opposition to the tranquillity that emanates from *SOE 1–8*, in *Eight Joined Elements Describing a Flattened Cube* the element of relaxation is fighting powerfully against the restraints set up. The result is almost explosive, wild beasts straining to escape their cages. It makes you uncomfortable, this turbulence, because the metaphor is so clearly one of conflict. The restraining boundaries seem impossible, but they do still restrain. Plank seems to be renouncing the tender trap of safety. He has quoted Alan Fowler on Systems art: *The work is intended to project its own essential qualities rather than being an expression of the artist's own personality.* This may or may not be the intention of this artist, but in the finished work it is not so. Whatever the intention of the artist, their personality always shows through.

In all the references to Systems art in this country, the term 'British' is always included. Occasionally even 'English'. Might there be an Anglo-Saxon dimension? Something that points to an integrity, a clarity of vision, a directness and a strong sense of cultural identity, which somehow reasserted itself within the framework of an art movement that flared brightly and briefly and then faded? Is it possible that, having paid a good deal of attention to art's transnationalism (which certainly reflects the way the world has moved, as art always does), we have lost something of the specificity that is so necessary to art?

Tess Jaray, Drawing for *Blue Rain*, 2008

At what point in a sequence – as in one to ten – does change occur? At what point in the repetition of a shape does it change its nature? It has been observed that a sequence of seven repeated identical shapes is needed before each shape loses its identity and the sequence becomes a field. The magic of mathematics and geometry will only be expressed when the artist is also a magician. The most interesting question is not to do with the nature of form, but rather: 'What happens if...?' Then sequence and repetition may be transformed, become a journey, a search, and sometimes a discovery. Mathematics turns into nature. A daisy has a number of petals. All alike, all different. They grow in sequence. This doesn't make daisies art, it makes them daisies. But of course sequence and repetition do not make art. Artists make art.

Tess Jaray, Drawing for *Per Tutte le Madri*, 2008

From a certain moment you work with constituent parts. In my case, repetition after repetition of very simple shapes. You shift them and change them and move them until something happens – asserts itself, asks to be born, takes me over, *becomes* me. And at its point of completion there seems to be no space between the image and myself. This may just be the result of years and years and years of trying, of working towards something just somehow out of reach. You could call it maturity, or you could call it senility, but it has a rightness about it – for me anyway. This is a procedure that I've followed to some extent all my painting life, except that it used to be done with pencil and ruled paper, then pencil and graph paper, and now the tool is the computer. They were, and are, all tools of their time. So in some ways the process has not changed much, but now I don't have to try so hard, perhaps because I'm more familiar with the language, perhaps because my eye is faster at detecting new possibilities. Because there always has to be a new possibility; if things are repeated too much they lose all life and die.

The courtyard in Tangiers

The courtyard in the Medina was tiny. It was paved with worn old tiles, with a blue and pink pattern, many of them loose or lying around. There was a well – working – and a single lemon tree with small, shiny, green leaves. And there was a gas cooker: why cook indoors when the courtyard is open to the sky and the sun is shining? The walls were washed with white paint, and the rooms leading off them were also tiny. They contained only banquettes, both to sit on and for sleeping, which were covered in patterned rugs, mostly in a deep red pattern. One room also had a table and some chairs, and a large television that was always on loud, usually playing the football.

For lunch we had the most exquisite chicken with couscous. We ate with the fingers of our right hands, and from time to time they would pick out the best bits and put them on our plates. Then I was permitted to hold the baby on my lap, which gave me great pleasure: she was at that solid age that makes cuddling so rewarding. But when she weed on my lap it caused them great shame and consternation. I felt sad for them, because that is what babies do.

They were very excited about selling their house. The Medina was too dirty, there were too many people, everybody knew everybody else's business, there was no privacy. And they were going to buy a newly built apartment in a new development, all new materials, breeze-blocks instead of the old mud bricks and a proper modern supermarket some way away. It was certainly a step up socially. They would have some privacy,

they wouldn't know their neighbours and the door didn't open from a courtyard straight into the street, where there was always someone poking their nose into your affairs, even if you had only bought some tangerines or olives. Thank goodness plastic bags were now made of black plastic, so at least no one could actually see what you had bought. They were asking such a small sum of money for the house that I fantasised for some time about buying it. But I couldn't live in two places at once, and what would I do with it, even if I could find the funds?

Two years later I returned and met the family again. They were unhappy. The old grandmother was lonely because she no longer met her friends and neighbours when she went out to buy bread. It was too far from the Medina for anyone to visit them. The supermarket was a long and ugly walk away and she didn't know anyone when she got there. The breeze-blocks were too hot in summer and too cold in winter. Having a proper kitchen somehow didn't make up for the loss of the open sky when she was cooking, and the smell of her food mixed with that of her neighbours. But still, socially they were now a cut above those who remained in the Medina.

Rosso Fiorentino, *Deposition*, 1521. Oil on wood.
Pinacoteca Comunale di Volterra

On first seeing Rosso's *Deposition* of 1521, it seemed to me rather strange that this astonishing painting, although famous and celebrated, has not become iconic in the way of others of that period. Maybe its location is just a little too far off the beaten track. One of those classic Tuscan hill towns, high up a winding road, smothered in mist in the mornings, Volterra is possibly more famous for its alabaster than its paintings.

Maybe that confusing description 'Mannerist' has put people off making a special journey to see the *Deposition*. As far as I understand, and I am not a historian, the term was not originally one of abuse. Later on it was used negatively, to describe something as being 'in the manner of', decadent even. So it was not really a concept at all, more a loose and arbitrary name for various styles that had no ready-made label. 'Grand manner', as the *Deposition* was described by contemporaries, seems to be closer: something visionary about the painting was perceived, anti-classical, a break away from the tradition of Renaissance figuration. In some of Rosso's other works, for instance the little painting of a putto playing a lute that hangs in the Uffizi, there is a charm and a sense of mischief, a light-heartedness or whimsy, that is absent from his *Deposition*. In its simplicity, forcefulness and rebelliousness, this is the work of a young man aiming for – and achieving – a masterpiece. He was only 26 when he made it.

The museum in Volterra shows the painting perfectly, alone in its room apart from Signorelli's *Annunciation*, which, although beautiful, does not really ask to be looked at for long. The Rosso

is lit in such a way that the theatricality of the painting itself is reinforced, and seats are placed in front of it so that viewers may immerse themselves in its large – nearly four metres high – arched form. And then you find yourself, visually, working quite hard. This is a complicated painting, with a great deal to look at and a great deal to puzzle out. An enormous number of things are depicted, and where not depicted, suggested. However, it shows at the same time a radical simplification and flattening of form. Interestingly, this difficulty of grasping everything in the first moment of looking – which is one of the special, and sometimes great, characteristics of painting – involves you in unwrapping and interpreting the work. You become immersed in it, caught up with it, perhaps even become part of it, as much as this is possible with something that ultimately is pigment on a flat surface.

To begin with, its theatricality is startling. The figures appear to be 'frozen' in a moment of time. But only very briefly. The impression is that when you look away they will explode and vanish. They hardly seem to be painted; they look as if they were carved out of the surface of the canvas. With its simplification of form and structure, the *Deposition* is, for me, Modernist rather than Mannerist. The planes of the painting are so greatly simplified that it is difficult not to feel that this is the start of the formalism that took hold 400 years later. But not for a minute does this diminish its emotional impact, which is achieved not just through the size and power of its forms, but also through its intense, saturated colour and the expressions of the figures.

Although the influence of Michelangelo is evident – this was to increase in Rosso's later work after a period spent in Rome

– it is not there in the play of light, which is graduated very differently in Michelangelo's work. The forms that Rosso used to describe the drapery are harder, more distinctive, abstract even. They are also less linear. Edges are demarcated by tone and colour, not by line. The colour, as with the forms, hovers between beauty and brutality. Reds, blues, yellows, oranges, blacks and whites – there is almost no green – are all fierce and deeply saturated. The contrast between black and orange on the top-left figure has the force of fire. It seems that only the blue and yellow sash prevents this man from bursting into flames. The intensity of the colours appears to be born out of the forms; this is what so many artists aim for, and it is so difficult to achieve: the correct colour for each form. In paradise there will be a book for artists with each form described and its appropriate colour next to it.

The colours of the *Deposition* are individuated and flattened, in contrast to sixteenth-century formal conventions. Very few concessions to tradition are made. The sky, for example, is unusually uniform and without a cloud. There is landscape, but so little that it does no more than define the context, with tiny soldiers just perceptible. Only the figure of Christ is differentiated in colour. Here the colour is not 'local' but generalised, and the face and body have an overall tinge of green. There is no more life in this body. Some have said that Christ is smiling, others that he wears the grimace of death. But I see it more as a face depicted at the point of death, the expression a mixture of relief, peace and the alleviation of pain – very powerful. The other faces are also strongly expressive, and their expressions are at one with the bodies that express them. Agony runs right through the painting. This is very different from an artist such

as Grünewald. In his *Isenheim Altarpiece*, painted just five years before Rosso's *Deposition*, each brush stroke is an expression of pain and interpreted as such. There is nothing of Grünewald's grotesque in the Rosso, and yet it is hard to fathom how Rosso's almost abstract, sculptural forms do the same thing, in their anti-descriptive way.

Because of the expressiveness of the figures, it is easy to underestimate the power of the geometry that holds the work together. The figures are not modelled. They are carved out of a single plane, within which their bodies, clothes and faces are depicted with different and inventive uses of geometry. There is a great tension between top and bottom: the figures may be seen like fruits floating in syrup, pulling against one another. The billowing cloak of Nicodemus pushes the painting upwards to its limits. Against the descent of Christ's body this great upward curve surely suggests the ascension of the spirit. And the ledge that has supported Christ's body creates a point of stability right in the centre of the painting, without which all else would remain forever in flux. Here Rosso reconciles so much that might at first glance seem impossible: a tension and an equilibrium between the violence and expressiveness of the subject and the formalism of its presentation.

The figures, the structure of the cross and the three ladders are totally intertwined, enforcing the powerful geometry of the whole. It is not easy fully to grasp the presentation of each figure. As in a puzzle you have to disentangle them to work out which head belongs to which body or which arm to which hand. As a result, you are drawn closer and closer into this great drama. It is as though you are *there*. You perceive the expression

of each individual figure, realising that each is so unified with its figure that it seems absurd to apply the term 'Mannerist' to this work, which has no affectation or superficiality, nothing false. Above all, the painting is charged through with a forceful sense of morality, something almost stoical. This, I believe, gives it a strength, a fierceness, a probity that make it stand with the greatest of all paintings of this subject.

It may be imagination, fantasy or even wishful thinking that makes me see the *Deposition* as having opened the door to Modernism. Perhaps it is because it has no airs and graces. There is nothing corrupt about this painting. It has the immediacy and directness of modern ways of expression. Surely there is a connection between Rosso's sculpted forms and those of Picasso's *Demoiselles d'Avignon*? It seems impossible to believe what a furore that painting created in 1907. But we all know what a crafty artist Picasso was: not much escaped that beady eye of genius. Did he travel to Volterra? Did he need to? Rosso's *Deposition* seems to me to stand somewhere between Giotto and Picasso in its power and search for essentials, for what is fundamental, instinctive and intrinsic to us, for that which joins mankind to the earth.

Passing Clouds cigarette packet

32. PASSING CLOUDS

My mother had a particular grain in her nature that is hard to describe. It was to do with her ability to gain the most, the absolute most, from any experience that promised pleasure. I am thinking here not so much of those things that nourished her spirit, like music or poetry or the many different kinds of love of which she was capable, indeed that constituted her being. Rather, I am thinking of the small, everyday, life-enhancing pleasures that she had honed to a fine art in order to extract the maximum amount of satisfaction from them.

Sun-worshipping took priority. It is necessary here to grasp the degree to which Pauli understood the behaviour of the sun. Galileo could not have had a closer insight into the sun's power and patterns, its magnetic field and speed of light. She knew that it is stronger and more dangerous in the spring, when its ultraviolet emissions are higher. That our human timescale is artificial: midday by our clocks is only eleven by the sun, so not yet as dangerous as one might think. That in late summer you can laze in the sun for hours without harm. That you must be very careful if there is a breeze, for the rays of the sun cannot be felt and are therefore particularly dangerous. That you should always protect your eyes (in place of sunglasses she took a leaf – there is always one handy – shaped it carefully and placed it over her closed eyelids), and don't forget: always cover your head.

Those were, of course, the days before the ozone layer and global warming were discussed, with all the dire warnings that have besieged us in recent years. She laughed at all that

when it began, as she laughed when scientific discoveries were broadcast with such seriousness, only for the reverse opinion to be broadcast a few years later with equal seriousness. But she didn't take unnecessary risks with the sun. Steadily and carefully she rubbed cream into her skin, smoothed her arms and legs, and prepared herself for the sun's restorative powers. She would find exactly the right spot in the garden, place herself at exactly the right angle; not in order to achieve the perfect tan, but to absorb the sun's life-giving rays, to feel its warmth and glow, and feel her body in tune with the earth and the sky. The full pleasure of this experience, naturally, could only be achieved completely naked. The secluded garden, with its high hedges, and the silence that betrayed any footsteps made this wonder possible.

There were other pleasures that provided the order and ritual that Pauli needed in her life. Oddly enough, eating and drinking were not really among them. Certainly not drinking. In our family a bottle of wine sufficed for about a year. In my parents' carved wooden drinks cabinet (this is the giveaway, a serious drinker keeps the bottle well hidden under the kitchen sink), there still remains a bottle of 50-year-old Gordon's Special Dry London Gin, dark green glass with a metal top and a plaited metal clip. Perhaps it will still be there in another 50 years. My father very much regretted his inability to drink; he felt that in order to be one of the boys you should be able to down the required number of pints. On one memorable occasion, when he was away at a conference with some hardened drinkers, my mother speculated about how he would manage. I had 23 tomato juices, he reported on his return, with an unfamiliar tone of humiliation in his voice.

But *smoking*. Ah, that was something else altogether. All her life my mother smoked, having started, she told us, at age eight. A helpful doctor had suggested it might protect her from tuberculosis, which was rife in Vienna at that time. Perhaps it did, for she never caught that dreaded disease. She always smoked the strongest variety of cigarettes, Players, with no filters. But not very many. Too many throughout the day would defeat the purpose, she explained: pleasure, not necessity. Often she smoked just half, carefully keeping the rest for later by placing a penny – one of the old kind, with copper in it – on the tip to prevent it burning up. And she didn't smoke while doing other things. She created a special space around the ritual, often sitting down the better to concentrate, so that the euphoria of inhaling and exhaling could really be possessed. There was not only ritual in this activity, I felt as a child, there was also grace, and something else, something to do with the secret of being grown up.

And then there were the days – halcyon days – of Passing Clouds. These Egyptian cigarettes came in a flattish, bright pink packet illustrated with an oval picture of a cloud passing across a blue sky. At least, that is how I recall those packets; I haven't seen one for many years, and when I looked the brand up on Google recently, its pink packet bore a picture of a cavalier. The cigarettes were not cylindrical like ordinary ones, but oval, curving almost to a point at the sides. I was reminded of them recently when I went to a lecture on the structure of ovals and the difference between ovals and ellipses, a concept not entirely simple to grasp unless you have an eye for geometry, which I feel I ought to have but actually do not. But it gives me great pleasure to consider the connection between the miraculous oval ceiling

of Borromini's San Carlo alle Quattro Fontane in Rome and the Passing Clouds cigarette.

For many years Pauli smoked one of these a day, just before going to bed. I remember its unique fragrance, and that she gave herself up to it, briefly removing herself from the world. Only one: more would have been beyond her means, an unnecessary extravagance. Until that ever-to-be-regretted day when they ceased to be manufactured. She put an advert in *The Times*: Wanted, any packets of Passing Clouds still available. A kind man answered from Oxfordshire and she acquired a carton of ten packets. From then on it was just one a week, on a Sunday morning, in bed after a cup of tea.

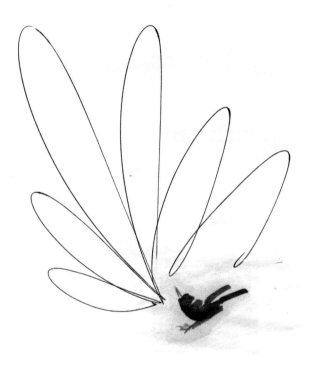

Tree sparrows

33. IT MUST BE ADMITTED

It must be admitted that this little piece has nothing whatsoever to do with my paintings, although the original idea was to offer an extension, if not an explanation, of them. But the subject is such a wonderful example of the marriage of betrayal, morality and practicality that I wish I could connect it with the paintings in some way. It concerns the tree sparrow. A little smaller and rather shyer than the house sparrow, this is a bird most modest and unassuming in appearance, although it may be an indication of character that its tail is almost permanently cocked. Really, just a little brown bird, with no special markings to show that it has morally progressed ahead of humankind. These birds mate for life, and both male and female brood the eggs, so it is a real partnership. They clearly love each other. However, from time to time the female experiences an irresistible urge to wander, to visit a neighbouring tree and have it off with a handsome young unattached male. When she returns to her mate, he doesn't make a fuss about where she's been or why she's late. And if he wishes to take advantage of his husbandly dues, he just gets behind her, asks her to raise her tail and quickly pecks out any evidence of her little adventure. Then he can fulfil his own desire. This way he can be sure that there will be no paternity suit when the eggs hatch and the family will remain in harmony.

Ken Draper laying a hedge

I swore to myself that in these pages I would not write about anyone still living. Not even my sister, who devoted years of her life to caring for our mother at the end. She has her own memories and it is not for me to trespass on them. But there has to be one exception – K, who for my mother, and indeed many others, represented the continuity, humanity and nobility of the British character. For many years he has been the local postman, delivering the mail between six in the morning until the early afternoon. After that his days are spent mending fences, mowing grass, felling or planting trees, digging vegetables, potting flowers, cutting nettles, clearing out cesspits, making bonfires, mending gutters, repaving paths and repainting sheds – doing all the many things for which people in the village no longer have time or inclination.

He did most of these things for my mother too. But he also painted her bathroom, put up shelves, watered the tomatoes, swept the leaves, pruned the roses, unblocked the sink, brought her the newspaper, took her shopping, and exchanged recipes, pot plants and gossip. After my father died, the garden became K's creation. They had worked on it together since the 1960s, when K was employed for six shillings an hour. Those early years were spent pruning the fruit trees in the orchards, putting the fruit in trays to last the winter and cutting the grass with an old Allen scythe. The garden is about an acre, if you include the steep bank with the trees and shrubs planted by my father and K. Camellias, almond trees, silver birches, wild cherries, holly,

oak, rhododendrons, japonica, spirea, forsythia, lilac, snowberry, flame trees, azaleas, tree peonies, syringa, magnolia, morello cherries, laburnum. And ferns, daffodils, bluebells, cowslips, buttercups and primroses in the spring. Not grand or formal, but not self-consciously cottagey either; grown so that its form constitutes an essential rightness, as though inevitable, sprung naturally from the earth without any effort.

The house itself sits on a small plot of flat ground that only briefly interrupts the steep valley in which it is set. There were said to be 25 houses up that lane at one time, and a ford crossing the river, but just five houses remain, of which only my mother's preserves the best of the past. At the bottom of the valley there is a weir, with the remnants of a ford, and parts of what may have been a cider mill, like the one left in the garden under the great yew tree that is believed to be at least 500 years old. My mother loved to sit in this perfect and ever-changing garden whenever possible. She herself was never a gardener. The garden was somewhere to sit and sew and be part of the landscape. And K looked after it, doing all the things necessary to keep it part of that landscape.

But to my mind, none of these things are as wonderful as his talent for laying hedges. This is now almost a lost art. Councils across the country employ contractors to go up and down the roads, lanes and byways cutting, or rather tearing, the hedges with machines. The torn branches of the hawthorn, holly and hazelnut stick up into the air, looking bitter and bereft. But not K's: his are *laid*. First, young hawthorns are planted. Two to three feet high and two feet apart. Then, after about four years, he 'sides them up', which means tidying them, and then they are

pleached, a kind of threading and weaving of the stems. To do this, he cuts three quarters of the way through each main stem then weaves them between hazel or split-willow stakes set about two feet apart. To finish off he 'heathers' the hazel. This entails twisting long switches of hazel, with the twigs still on the end, around each stake to keep the hedge in place while it is growing. The stems must always grow uphill, so that the sap will rise.

This is slow work, requiring patience and an eye for beauty and the proper use of nature's gifts. It is not for those who do not know how to use their hands or their eyes, or those who are bothered by a few scratches. It is a task for a person who is in harmony with nature, and it must be seen as a labour of love. Why this seems such a rare thing now, I am not certain. It is not as though K goes without modern pleasures: the pub and the lottery are certainly as important in his life as hedge-laying, not to mention astonishing wins at the races and spending those winnings on a microwave or a trip to visit his son in Australia. He does all these tasks quickly, but never seems to be in a hurry. He knows everything about everyone in the village, but his chat is never gossipy or malicious. He rarely says a hard word about anyone, but he is not remotely righteous, and although wonderfully faithful to his loving wife, I believe, he is not without an eye for feminine charms.

Is K's harmony to do with the country versus the city? Age over youth? Class or culture? Nationality or geography? Now against then? I think not, because I cannot help thinking of K in the same way that I think of Leopold known as Gixi, although this may sound absurd. Such people are life-enhancing and life-giving, and they resist the sweeping tide of cynicism that

often seems to be engulfing us. K's mother is still alive, at a very great age. Every morning, when he passes her house on his post round, he stops his red van and goes in for his breakfast, which his mother has ready at that precise minute each day: fried eggs, bacon, tomatoes, toast and marmalade, and tea.

Nancy Adams in front of her cottage

I'm not sure where the eccentrics have gone. I hardly seem to know any nowadays. I've just looked up the word eccentric in the *Oxford English Dictionary*, to see if it can throw any light on the matter: departing from the centre; out of the usual course; not conforming to common rules; odd. Well it does help a bit, actually.

I'm searching for a way to describe the people who lived in the four cottages next to my parents' in those early days. Some of them seemed so peculiar, even then, that I fear any description would be thought of as a fabrication. But there is no fabrication here; I can't do it even if I wanted to. Admittedly I can't say this is the truth, the whole truth and nothing but the truth, because it certainly can't be the whole truth, whatever that is. But otherwise everything that is described here was the case. (I was once told by someone that in philosophic terms *everything is the case*, a concept that I found charming. But when I mentioned this to a proper philosopher, i.e. one who earns a living by it, he put me in my place by telling me that in true philosophic terms it has been proven that everything is not necessarily the case, that Wittgenstein had in fact said: *The world is everything that is the case.*) So I will just say that these neighbours had 'departed from the centre'; they were 'out of the usual course'; and several were certainly 'odd'.

When I mentioned this interesting question to my friend K (no relation to K of the hedge-laying), she said that of course there are fewer true eccentrics now, for there is no longer any

norm in the way there used to be, and probably this is a good thing. But she also thought that the complete loss of eccentrics would be very regrettable. In any case, those old neighbours, and they were mostly old, at least to me, were certainly eccentric. I have already written about Billy Adams, although as an artist he probably didn't count. But Professor M, for instance. He was, we were told, a brilliant scientist who taught at a university some thirty miles away. No doubt he was brilliant, but he was so shy it took him twenty minutes to say good morning. And after his middle years he adopted a kind of mimicry. He mimicked old age, and took on the demeanour of a very old man, shuffling, head down, inarticulate. His mother had also been 'out of the usual course', not so much for spending all day gardening, but rather for the large straw hat that she never removed in company. We used to say that it had hair attached to it, speculating that she didn't have any of her own, for when we called at their house, we always saw a hand snatch up the hat, lying partly visible on the window-sill next to the door.

In one of the houses there was a wealthy man with a housekeeper, with whom he lived, it was said at the time. I could never understand why this fact was whispered: of course he lived with her, it was perfectly obvious, why whisper? Then there was the truculent Mr N, with whom my father had a tremendously enjoyable feud over boundaries, fences, rights of way, gates opened or closed. But he must have been rather more than truculent, as late one evening one of his sons paid him a visit, knocked him down and then went into the woods and shot himself. There was also the neighbouring farmer's daughter, L, who was my best friend. She couldn't really be counted as eccentric, but she did

me the kindness of explaining the facts of life, and as she had observed with great interest the coupling of cows and pigs on her father's farm, her explanations definitely did not 'conform to common rules'.

The most wonderfully eccentric of all was old Mr B. His cottage was the lowest in the valley, tiny, with just one room downstairs. I saw him quite often as I used to call there to play with his little granddaughter, and he always, always opened the door to me with the terrifying words: Come for a good hiding, then? He never went to bed, but slept in his chair in the living room, covered with a blanket. Of course there was no bathroom, so I must assume that he also never washed, although that didn't occur to me at the time. His occupation, or rather all-consuming passion, was fishing. He went fishing 365 days of the year. Occasionally I spotted him sitting immobile among the reeds and willows on the steep banks of the river, multi-coloured dragonflies flitting around (now they seem only to be black, for some mysterious reason of mutation), his gear next to him – rods and nets and buckets in which slimy things wriggled. I never saw him catch a fish, but in his single room there was an enormous pike, stuffed and framed proudly in heavy mahogany over the fireplace. Leaving the house once the back way, through a kind of shed, I came across some large sacks. At that age they came nearly up to my shoulders. When I touched them, they shifted slightly. I don't really care to remember this, but they shifted slightly because they were full of maggots, which old Mr B bought by the sackload as bait for his fish.

My parents fitted well into this place. My mother mentioned once that even in Vienna they had been considered unusual.

Pauli's cat Marbles

36.MARBLES, OR THE LAST LOVE

I am appalled at the thought of writing about a cat. Not that I have anything against the beasts; on the contrary, although I should admit that I'm not really even very keen on pot plants. It's just that I do seem to have a number of friends who are besotted with their cats, and who seem to honour me rather often with stories of their darlings' exploits. But Marbles was so big a part of what I believe to be my mother's happiest decade, her eighties, so much her partner, child and lover all in one, that I would be presenting an incomplete picture of her without presenting one of him as well. So this is also a portrait of their very particular love affair.

First, I suppose, honour where honour is due. He was a very handsome cat, a large tabby. And to demonstrate his great superiority to other cats, he had six toes on each of his two front paws. This made his paws appear very large and, judging by the cockiness with which he carried himself, gave him status in the cat kingdom. He had actually been my father's cat, but after my father died he knew exactly which side his bread was going to be buttered, for he instantly transferred his attentions to my mother. With her loving nature, she took this at face value, disregarding his blatant self-serving hypocrisy, and soon gave him first place in her own affections.

I think he must have been hoisted with his own petard: his shocking behaviour towards my mother suggested that he had fallen so much in love with her that his jealousy knew no bounds. This sometimes took the form – very unintelligently, I thought

– of taking large bites out of her leg, or whichever of her limbs was nearest. In fact, the expression 'biting the hand that feeds you' often came to mind. She was obliged to use a pair of my father's old gardening gloves to handle him when he didn't want to be handled, and to have regular anti-tetanus injections.

It made no difference to Pauli's love for him. Being a widow, if also a free and happy one, she took her meals alone. Alone, that is, apart from Marbles. He sat next to her on the table and was served first with all the best bits of food. Naturally, the menu was chosen for his benefit. Lamb chops, of which the tender, pink part went to him (she was left with the bone and gristle). Fish, which she didn't care for much herself, was filleted and carefully placed on his dish. On the table. Of course, she denied all this when I came to stay, but the evidence was all too clear. Marbles was in a furious temper, being too thick to understand that it was only while I was there that he was relegated to the floor and denied his rightful place at the table. Or rather, on the table. But he was not denied the food, oh no: six meals a day, full-cream milk specially ordered so that he could have the rich top. And if starvation threatened between these meals, if he had been too lazy to catch himself a mouse or rabbit (and the place was *black* with them), my mother put a special plate on her tea-tray so that she could share with him her cake or scone.

I knew that the balance of power between Marbles and the family had shifted when one day I noticed that the photographs my mother kept on the old oak dresser in the living room looked different. For years there had been snaps of her children in different poses, and then of her grandchildren, the eldest of whom resembles Helene, Pauli's mother, in appearance if

not in character, while the youngest has inherited much of her disposition from her grandmother. Some photographs of Marbles too: it was perfectly natural that she included her cat in this display. But that day I noticed, with disbelief, that the only pictures remaining were of cats – of Marbles and a few smaller snaps of his predecessors. I was outraged.

My own natural, and rational, jealousy at my mother's obvious preference for her cat over her only eldest daughter came to a head when I arrived to stay and looked in the fridge to see what there was to eat that weekend. Nothing, as far as I could discern. Ah no, there at the back of the fridge was a tin of very expensive-looking pâté. 'Gourmet pâté', it said on the part of the label that I could see. So she does love me best after all, I thought, taking out the tin to examine it. 'Gourmet, cats' special'. My mother was very apologetic and didn't laugh at me at all, at least not to my face. But it taught me a useful lesson in love: best to know when you are beaten.

Marbles made her suffer, too. Although he had been neutered, some primeval male urges seem to have remained, for in the summer months he regularly disappeared, wandering the countryside, I can only assume, to seek what was missing from his life. Six, seven, sometimes ten days went by, during which my mother went into mourning, something she certainly didn't do after my father's death.

Night after night I telephoned, to hear the same mournful news: no news. And I remembered only too well that when my father had been away on one of his many trips and was late home, say ten minutes late, she happily reorganised her life as a widow in her mind; who knows, perhaps she even imagined herself

sitting in his chair, and was a little surprised when he appeared just eleven minutes late.

The worst, the very worst, occasion was when Marbles had to have an operation on his paw, after a tom cat for once got the better of him. I arrived for the weekend one gloomy November evening. The house was in complete darkness. Normally the lights were blazing, Pauli was peering out of the window ready to welcome me and the place was full of her presence. This time, nothing, no sign of life. Overcome with fear, I ran through to her bedroom. There she was, the lights dimmed, bent over Marbles, holding and comforting him with both arms, as he lay there in a state of profound and impotent fury with a flowerpot around his head. It's a terribly clever device that vets have invented: with a flowerpot around its neck an animal is pretty helpless. There was nothing Marbles could do about it: the cone just had to remain there until his paw was better, and remain it did. If there is just the slightest touch of *Schadenfreude* in this story, well, it must have just slipped out.

He became fat, of course. I named him Caterpillar, which made everyone cross. He spent most evenings on my mother's lap, so she couldn't get up to change the television channel for fear of disturbing his comfort. This way, she said, I get to watch some very interesting programmes that I wouldn't otherwise have thought of watching. (Although she never actually became used to having a television – she was at least 70 before we could persuade her to acquire one – and now that I think about it, she was never quite at ease even with the telephone.) Marbles also slept in her bed at night. At least, he did when he felt like it. When he didn't deign to join her

she felt like a rejected lover, and when he did, it was as though the man of her dreams was lying softly beside her.

So there they were, living together in this fecund and glorious part of the English countryside, both more or less in their eighties but in terrifically good health. And they were very happy as a couple for many years. Pauli was determined to outlive Marbles, for she could not tolerate the thought of him pining after her (and she did, just, although it didn't seem to matter so much at the end). Most days throughout the summer months she sat in the garden, in the shade of the reaching laburnum tree when it was hot, out in the full sun overlooking the steep valley when the temperature was right, always with the little bag that she had made herself from a beautiful woven fabric that I had brought back from my travels. In this bag she had everything she needed for however long she was going to be in the garden: a handkerchief, sunglasses, cigarettes (those very strong ones without tips) and matches, and of course whatever she was sewing. There she sat, sewing, with Marbles under her chair for company. As my friend A once said, she was outrageously content.

Peter Keen, *Samuel Beckett*, 1960s. National Portrait Gallery, London

I thought that the saga of the fox was finished, but at the back of my mind there was an old experience trying to surface. Something that reminded me of that primeval moment of exchanging glances with her. And then I remembered: 50 years ago this year – perhaps it was to the day and memory takes note of these things – I was in a dark and smoky café in Paris. It was small and atmospheric. I felt my chair pushed and, turning round, stared straight into the eyes of the man behind. His gaze was penetrating and predatory, like the fox. It was Samuel Beckett.

Alison Wilding, *Largo*, 2002. Cast cement fondue,
fabricated silk and paper blooms

In this piece I am attempting to make sense of my response to a selection of sculptures by Alison Wilding, after seeing them recently in the Duveen Galleries at Tate Britain.

Her work has been much celebrated, and mostly in such cases I would have little to add. Far more fun to feel that one has seen qualities in an artist's work that have been hidden from others, to draw attention to something previously overlooked.

But although Alison Wilding's work has by no means been neglected, it seems strange to me that so much of the discussion around it is related to her use of different and contrasting materials. This of course is true, but it is self-evident, and seems to explain very little about why her work is so affecting. After all, in the world we live in, we are forever surrounded by contrasting materials, and most of us are affected, unknowingly, every minute of the day. Probably just as well that it's unknowingly: if we were to notice our responses every time it rained softly on a hard pavement, or when we brushed dead leaves into a metal bin, or jumped at the touch of water on our hands, we would become confused at the very least.

In art, to make materials resonate with meaning is difficult. But Alison Wilding does more. Much more.

It is true what some have said: that in her work there is an endless dialogue of opposites. But this is not so much in the contrast of steel and concrete, copper, oak and lead, or rubber and silk and paper roses, as in what she has enabled them to express, without losing the autonomy of their material existence. She

obliges us, through means impossible to grasp, to look at them in other terms. To see brutality and vulnerability, to see hardnesses, each different hardness forcing us to ask: what is hard? And by implication: what is soft? In material and in feelings. She obliges us to be aware of a fierceness, almost as if to assert a sense of morality in the face of a rocky world.

This is not an easy way to look at sculpture, but easy is probably the last thing she aspires to. Demanding is much closer a principle. And nevertheless, in the works that are comprised of two parts, there is great beauty in the tension between heaviness and lightness. The heaviness is always on the point of taking off, and the lightness seems always to need to remain rooted. Both holding their ground, waiting.

There is something here that is not unlike the horror of recognising the beauty of war machines: that against one's will one can still see, in the flight towards death and disaster, the 'edge of beauty' so very close to the edge of terror. This is described in philosophic terms as looking into the abyss. As Nietzsche famously said, when you gaze long into an abyss the abyss also gazes into you.

Sometimes all this underlies the most prosaic of forms. For example her use of the circle in *Vanish and Detail* – made with precast concrete, stainless-steel discs, paint and card – presents her understanding of this most difficult form, which is so complete in itself that, like the sun, it is autonomous. But here she subverts this obstacle, in such a way as to make it seem almost an act of revenge. She *offsets* its containment, makes it a point of escape. The circles are not centred, and they appear to exist together, almost in defiance, there only out of necessity.

There are other things that we can't help feeling in front of these works, even if, in our discomfort, we might rather move away. There is a particular force, attracting and simultaneously attacking, a force of becoming. There is temptation. And there are rejection and repulsion as well. How wonderful, to me, to see these aspects of humanity laid bare without ever being stated, without embellishment, without explanation. As though the work is saying: everything is forever held apart; there may be a longing for unity, but you are not privy to it, completeness is forbidden. You will be frustrated, but are permitted to wait and hope.

My own absolute favourite among the pieces at Tate Britain is *Largo*, made in 2002. Its placement in the centre of the galleries, bringing in the pattern of the floor and the ceiling light, even the capitals of the pillars, shows an understanding of the space in which art is shown that is very rarely seen. Although naturally I feel my responses to this piece are mine alone, I have learned full well that this is not usually so. Powerful art speaks to us all, and often overrides the individual response. So when I see in the roses in this sculpture an infinity of references, a penetrating sweetness mitigated only by their colours – black, greys, dark and light, dull greens; the three petals that sometimes signify inedibility in nature, simultaneously sinister and exquisite, with a warning against the dangers of frivolity but a deep pull towards it – then I know that this is what everyone else will also feel.

The profundity and subtlety of Alison Wilding's under-standing of particular aspects of human nature is unique to her works, or at least, that's how it seems to me. This is perhaps not an age for the profound or the subtle, but that doesn't mean that

we don't need these qualities in our lives, or that they affect us any less.

Alison Wilding uses the contrasts and the similarities of her materials not just to create metaphors, but to probe and dig deep into the human psyche, to point to our innermost conflicts. And sometimes these conflicts are revealed for what they are, and at other times they seem to be set on the path to resolution. Underlying even this depth of layering – for which, of course, her layering of materials is a metaphor – is a curious and unexpected feeling of acceptance. We are not obliged to understand what is accepted. The vagaries of life? The impossibility of remaining still? The impossibility of moving? The impossibility of not knowing? Or that there can be no resolution, no unity of feelings, and that we have to accept contradictions as the material and texture of our being. And, perhaps, the darkness of knowing itself?

It's all there in the work. You just have to be able to see it.

The ceiling light above the blue cupboard

I've been told by musicians that there is very little difference, in terms of maturity, between Mozart's early and late works. That there is no 'development', no creative leap forward, that his first works show as much complexity – as well as simplicity – as his last. Almost as though he knew that his time was to be limited. The example of Mozart makes it easier to understand, I think, that 'ageing' is not something that applies only to old age. We are ageing all our lives, and for some people turning 30 seems to hold more significance – even trauma – than reaching 70. After all, by then we've become accustomed to the mystery of passing years.

But there is a difference between working creatively early in life and later in life. In the arts, as in life, 'generations' are often referred to. 'The most promising of the younger generation', 'One of the most overlooked of the middle generation', 'Among the most prominent of the older generation' – it is said of artists, musicians, writers, actors. So we know that a young artist just starting out is not expected to have the word 'mature' attached to descriptions of their work.

To me there is something especially marvellous about the work of very young artists. It was one of the things I particularly enjoyed when I was teaching painting at the Slade. Everything was new to those students. The word 'idealism' had not yet turned into 'irony'. On the whole they still believed, contrary to all the evidence, that creativity, making art, was one of the noblest endeavours in which they could be engaged. Certainly that's what my generation thought – generation again – and

curiously enough I believe that it's still the case with most of the young artists: they believe in the value of what they are doing.

In those early years, discovery is the spur. As a young painter it is tremendously exciting to discover certain very basic facts about the business of painting. That red, for instance, jumps forward in a painting – it is the colour you see first – and a misty green will remain in the background. That applying some rudimentary laws of perspective, such as two lines starting at the bottom of a painting and receding to a point at the top, will give the impression of receding at a fast pace. That dividing the picture plane with a horizontal line will indicate a landscape, with a vertical line a figure or a door. That a diagonal movement is more dynamic than a horizontal one. At this stage, a young artist feels that only they understand this secret language. By the time their work has moved on, it has all become second nature and other problems take precedence.

I'm not sure which time in a creative working life is the best; presumably it varies according to the individual. But I clearly remember a conversation with Lawrence Gowing, a painter and historian who was for some years Slade Professor, and Barry Flanagan, the sculptor who sadly died in 2009 only in his sixties. They agreed strongly that the thirties were the most difficult years for an artist. You had the glory of your discoveries behind you, but not yet the confidence to continue in the same way. Maturity and real achievement still felt too distant, and all that seemed to remain was insecurity, uncertainty and rejection. A lot of that.

But as you begin to move beyond those years, perhaps into your forties – I realise these are absurd generalisations, but they are very much part of my own background; I could even use the

word 'trajectory' if I wanted to be pompous – something else starts to become clear. And that is experience. All those things that were a struggle to learn and absorb are now simple, second nature. You know how to stretch a canvas, take a photograph, apply plaster or watercolour, or be nice to whomever you hope will give you an exhibition. And perhaps you might start to think about why you are doing what you are doing.

After all, there are three big questions in this business of creativity: what, how and why. The first one – what – is not as silly a question as it sounds. Do you paint – and I am using painting as an example as that is what I do myself – what you want to paint or what you think you ought to paint? One mustn't underestimate the power of the new, that which is currently in the air, or even – I won't be forgiven for this word – fashionable. These are very important issues for young artists just starting out. Few people are strong-minded enough to stay clear of the pack and start off by going their own way. The need to be accepted by your peers is a powerful force. The how: paint, paper, larger, smaller, left to right, right to left, darker, lighter. This 'how?' will continue forever. And if you feel that you have something to say, why in this particular form? Why can't you just sound off to your best friend? The question of why is by far the most complicated. Why do it at all? Why start a life that has more knocks than most? In which there is unlikely to be much in the way of financial reward, or more than a moment of fleeting fame. All these questions, which you haven't been able really to understand until now, start to clarify.

You realise that you are not alone in all this. All the confusion, the quagmire even. On the contrary, you are part of

something enormous, of the longest river that flows through life. Creativity has always been an element of the lives of human beings. When we look at 30,000-year-old cave paintings, 10,000-year-old Middle Eastern pots, the remains of Egyptian buildings or the sculpture and artefacts of the Dogon people, for example, we can sense the special place that creators had in these different cultures. We can easily understand when we are told that they were born into their sacred trades, that their fathers and grandfathers had also done it – alas, grandfathers rather than grandmothers, I fear, but still, there was honour there.

And you start, also, to look at your own history. Is it something you want to escape in your work? Do you pretend that you are the first in your family to spread your wings in this way, to disown, reject, all that useless and irrelevant past? Or do you suddenly realise that the fact that your grandmother played the piano very beautifully, but only when she could escape from her domestic duties, that your father secretly painted watercolours in the garden shed when he could find the time, or that the letters discovered in the attic, written by some long-forgotten relative, are wonderfully eloquent – do these mean that the family genes that couldn't find any form of expression in previous eras have been passed on to you – that you have been given the luck and opportunity to use them?

You think about these things in your middle years, when you start to understand other things as well. For instance, the links that you have with other artists. Not just those you know, although your peers are of the greatest importance during your life. You begin to comprehend why artists throughout history have done what they did. You may speculate about those cave

painters, although perhaps we'll never know exactly what motivated them. Was it to influence their hunting? To magic their prey into existence? Just for the pleasure of representing that which was important to them? Or all those things. And you come to recognise the historical influence and power of the Church and the Florentine banking families, like the Medici, who commissioned the major artists of their day, as well as the limitations that those artists faced and how they used those limitations to create works of greatness. With this better understanding comes respect for all those who lasted the course, those who frequently made real sacrifices to do what they did. Where did they find the nerve, the passion, to throw what they had learned to the winds, to start from scratch, to become Cézanne, Mondrian, Matisse, Picasso?

And yet: although we may be older, perhaps more mature and wiser than we once were, how do we account for the myriad paradoxes and unanswerable questions about ageing and creativity? The fact that Masaccio was only 26 when he died, that Van Gogh and Raphael and Mozart were only in their mid-thirties, that Schubert and Wilfred Owen were even younger. The list could go on and on, which means that it is not only maturity that brings quality, and at no age is worldly success guaranteed. What if we ourselves die young? Will we have made enough to count? And why should it matter to leave something behind? But it does seem to matter to most creative people, even if they have children, so are assured that part of them will remain.

What about the *happiness* of ageing for those of us who have stayed the course? So many changes have taken place since those first baby steps in painting, as in so many other things. When I

was young I was sorry not to be invited to a party. Now I am sorry if I am. At one time I badly wanted friends to come and see what I'd done. Now that means sacrificing a morning's work – it can't be worth it. On the other hand, it seems a miracle to me that I have been permitted to spend my life doing what I like best. My immediate family, those who survived Hitler and the war, were not so lucky. No number of knocks or professional problems can diminish my fortune.

Early on, if one of my paintings failed, which happened more than frequently, life seemed hardly worth living. Now I know, or at least I believe, that if I put in the hours – which goes without saying, you always have to do that – sooner or later I'll solve those particular problems. The need to find out, to make discoveries in the work, still remains. This need is one of the strongest forces in the creative life, and I hope it never goes from mine.

It is true that I am no better a judge of my own work than I was in my early years. It still takes thought and looking and a bit of misery to make a judgement. But I comfort myself that I can now understand and recognise quality in others' work far more readily than before. And, I'm afraid, perceive where it is lacking, which reminds me that it is really rather difficult to create something that someone else might like looking at, let alone gain meaning from.

Some artists have a strong awareness of death, and perhaps that accounts for the magisterial late works of such artists as Titian and Cézanne. But for others, and I count myself among them, it just means that you don't want to waste time. I want to use and celebrate my days, not be distracted by unimportant things.

There isn't space here to delve into the fascinating question of how creative people deal with what might be called the 'shrinking of the heart' in later life – how a need for heightened emotions remains in order to bring something into the world. Tolstoy always had to be in love, with a young and lovely girl of course (his rather put-upon wife Sonya wouldn't do). But it is a very real need, vital to the creative instinct, and it must be supplied somehow, whether it's by a lover or a grandchild or a blackbird on the window-sill. Otherwise there is a danger that the heart will diminish.

As for stopping work, I don't see how that is possible. There is always the holy grail of the perfect work, the final, marvellous thing that you will do next, or if not next, then after that, or after that. Most of us must accept that it all has to be about the journey rather than the arrival. There is no Faustian pact available later in life. Mephistopheles is not there to bargain with. You might come to accept the limitations of your abilities, thus proving how mature you have become. Or not, as the case may be... And I suppose, finally, the most significant things I have learnt are that there is no end to the learning itself, and that there are no rules to follow until you make them yourself. Then of course you must follow them, even though no one else will ever know, or care, about those rules. But you know.

Originally read on BBC Radio 3, 8 March 2011

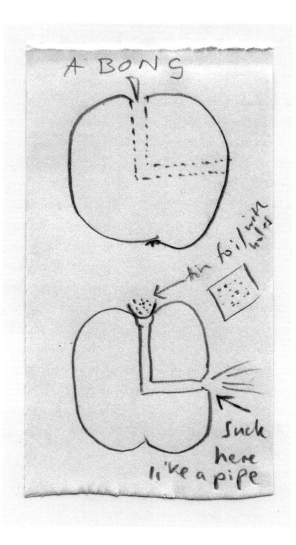

How to make an apple-bong

My father planted an apple orchard when I was a child. Cox's Orange Pippin, Worcester Pearmain and several other varieties whose names I have forgotten. We ate those apples all autumn. One single tree, a Keswick Codlin, was already there when my parents moved to the cottage in Worcestershire in 1942. In spite of the name – Keswick is in the northwest of England – I believe there were a number extant in Worcestershire and Herefordshire. This is a special apple. Mostly rather misshapen, yellow with a tinge of pink, it is highly perfumed and manages to be simultaneously soft and crisp. At the time it seemed to belong more to *The Arabian Nights* than that remote part of the country.

We, that is the children and their friends, were not permitted to eat from this tree. Some Biblical reverberations here perhaps. These apples were all for my mother. And when they dropped they were put in the barn on newspaper, each a little way from its neighbour so that any bad apples were contained. Eventually the tree died, and it was never replanted. So did the apple orchard, also never replanted, at least not with apples. At that time fruit trees were being grubbed up all over the country and replaced by imported foreign varieties. People preferred their clean look and didn't seem to mind their lack of flavour.

I didn't think about it again until some 50 years later, when I suddenly had a strange desire to grow one of these trees. I didn't know if they could still be found, but to my astonishment and pleasure the internet came up with a nursery. So four years ago I planted, in the centre of London, two Keswick Codlins. In spite

of being very young they yielded an apple that first year. I invited a couple of people to celebrate with me. We consumed the apple between the three of us; it was delicious and we all enjoyed the ceremony, although it didn't have the madeleine effect that I was hoping for. Wonderful as it was, the fragrance was not quite perfect – but still, it was celebratory. The next year there was nothing, but the following year – last year – the harvest was seven apples. I felt some pride, as it was a terrible year for apples: hardly any had grown anywhere, a bad spring perhaps. Although they were enormous, sadly they were too sour to eat raw, but they were excellent cooked with lemon and honey.

At the end of last year I moved house and the two Keswick Codlins came with me in large pots. This spring they blossomed profusely and dozens of tiny apples appeared. Alas, the tree in the front terrace dropped them all before they were ripe. On the back terrace, however, there were at least a dozen apples by June. Seven held for quite some time, but by midsummer all except three had dropped. These three I nursed morning, noon and night. Their green was so precisely the green of the leaves of the tree that sometimes it was quite hard to discern them. One of them grew heavier and heavier, and all three were by then an absolutely brilliant green, with no sign of yellow. I propped the heavy apple up with a forked stick to help the branch hold the weight of this monster. All to no avail: it fell before ripening. Nevertheless I picked it up – again it was much too sour to eat so I cooked it. This apple was fine, but not the celebration I had anticipated.

Now there are just two apples left on the tree. It rains and rains, and the wind blows, but still they hang there. Their colour

changes, but so imperceptibly that it's very hard to see that it has developed from a startling acid green to a green slightly – but only very slightly – tinged with yellow. This green is so even that the apples don't quite look alive yet. I can do nothing now but wait, and see what nature brings. Ten times a day I look out at the two apples, ten times a day they are still there, still green and still, perhaps, getting bigger.

No. I look out of the window and get a shock. There is now only one. I pick the fallen apple from the floor. It is bruised, has a hole where a wasp tried to get in and by no stretch of the imagination can be called beautiful. It is also sour. So it too gets cooked with lemon and sugar, and I add it to a damson coulis that I have made with bought damsons. They are such evocative fruits that I can't resist them, even if their sourness runs through my blood and nearly turns it into juice.

By chance, on that same day one of my beloved daughters calls me: she has been expelled from home tonight as her teenage son needs the place to himself – he is inviting a girl. I am in sympathy with him, as parents really have no place in the courtship rituals of their children, but of course it's annoying for her to have to spend the evening with her mother. So to make this a happier occasion I add the apple and damson coulis to cake and crème fraîche and everyone cheers up.

We discuss the question of the apples. Turn the last one into a bong, my daughter suggests. What is a bong? I ask, amazed at the depths of my ignorance. This is explained to me: it's a kind of pipe for smoking marijuana. You could bore two holes in the apple at right angles to each other and sit the hash on a pierced piece of foil in the top hole. Then you light the hash and inhale

through the other hole like a pipe. Simple! So that could be one happy ending for the apple saga. Except for the sad fact that I don't smoke hash.

The next day I wait to hear the result of my daughter's sacrifice. But teenagers are crafty and there is no evidence of what transpired. The last lonely apple still hangs on the tree, becoming greener and greener, but somehow always the same green. A week passes with no change. Then one morning I look out of the window, at the crack of dawn as usual. Something is different. There is a curious distinction between seeing something and seeing that it's not there. Looking out of the window on this rainy morning it takes a moment to register: the apple isn't there, it must have dropped. And indeed, there it is, nestling in the earth of the neighbouring pot, dirty but unbruised.

I ate it.

The lock on the blue cupboard

EPILOGUE: EVERYONE HAS
A BLUE CUPBOARD

At the end, in my father's old room, there was my mother and there was the blue cupboard. She probably didn't pay it much attention, for her world was fast diminishing, but it was there, and so it still is, part of her familiar surroundings. However, I have just had a dreadful thought: where should it go when I die? If I bequeath it to one daughter rather than the other, blood will surely be shed. I doubt that the judgement of Solomon – to cleave it in two – would solve that problem. I could leave it to the Victoria and Albert Museum, but I already offered them something, fifteen years ago, and although they said, how marvellous, we will write to you immediately, I am still waiting for that letter. Pauli didn't worry about such things, believing perhaps that love and better nature would sort them out. Maybe the best idea would be to follow her example, as in so much else, although it has taken me a lifetime to recognise the value of this inheritance.

She and the blue cupboard are intertwined, woven together in my mind like a filigree. There are so many people whose outside doesn't match their inside – or the other way round. With her, as with the blue cupboard, the inside gave what the outside promised. Even if the linen is changed, new towels exchanged for old, even if we all put our own fabrics on those shelves, fold them in our own particular ways, arrange them for our own satisfaction, the framework remains, something to hold onto always.

I imagine that everyone has a blue cupboard, even if it is not blue, or even a cupboard. Most of us have furniture in our heads; mine just happens to be blue, bought with 100 light bulbs and painted with time.

ACKNOWLEDGEMENTS

I am deeply grateful to Judith Ravenscroft, without whose interest and encouragement I would not have had the courage to publish this book, and to Sophie Oliver, for her sensitive understanding of what I was attempting to do, and putting it into readable shape.

Thanks to the British Museum for allowing the reproduction of Watteau's *Woman Seen from the Back Seated On the Ground, Leaning Forward*, and to *RA Magazine* for permitting the essay on Watteau to be reprinted. Thanks also to Kate Colleran, for her technical advice about Watteau's materials, and to the British Museum's Prints and Drawings Department for letting me view their holdings of his work.

Concerning the exit permit on the blue cupboard, I would like to acknowledge the amazing detective work of Louise Ramsay, particularly her relentless pursuit of the origin of the typeface, and Martin Stiksel for his help identifying the Austrian coat of arms.

The following people have generously agreed for their works of art to be reproduced in the book: John Stezaker (page 110), Patrick George (page 64), Richard Plank (page 138) and Alison Wilding (page 186).

'Patrick George: Plain Speaking' was first published by Browse & Darby in February 2013. 'Ageing and Creativity' was originally broadcast on BBC Radio 3 on 8 March 2011.

Text copyright © Tess Jaray, 2014
Copyright © 2014 Royal Academy of Arts, London

Photographs: Pascal Bergamin: front and back cover; © The estate
of Peter Keen/National Portrait Gallery, London: page 184; © Richard
Plank. All rights reserved: page 138; Sam Roberts Photography: pages
32, 88, 146, 148; Slade School of Fine Art, UCL: page 56; © Alison Wilding
2014. All rights reserved. Photo FXP London: page 186

Any copy of this book issued by the publisher as a paperback is sold
subject to the condition that it shall not by way of trade or otherwise
be lent, re-sold, hired out or otherwise circulated without the
publisher's prior consent in any form of binding or cover other than
that in which it is published and without a similar condition including
these words being imposed on a subsequent purchaser.

All Rights Reserved. No part of this publication may be reproduced or
transmitted in any form or by any means, electronic or mechanical,
including photocopy, recording or any other information storage and
retrieval system, without prior permission in writing from the publisher.

British Library Cataloguing-in-Publication Data
A catalogue record for this book is available from the
British Library

ISBN 978-1-910350-09-6

Designer: Georgia Vaux
Editor: Sophie Oliver

Printed in Wales by Gomer Press

Distributed outside the United States and Canada
by Thames & Hudson Ltd, London

Distributed in the United States and Canada
by Harry N. Abrams, Inc., New York